Reaching
Out

We dedicate this book to the children and their families with whom we have worked, for helping us learn not only the importance of school-home connections but also how to make those connections happen more often and in better ways. Our hope is that those who read this book will find similar meaningfulness, fulfillment, challenge, and joy as they engage in this endeavor.

Reaching Out

A K–8 Resource for Connecting Families and Schools

Diane W. Kyle ✑ *Ellen McIntyre*
Karen B. Miller ✑ *Gayle H. Moore*

Foreword by Roland G. Tharp

Skyhorse Publishing

Library of Congress Cataloging-in-Publication Data is available on file.

Cover design by Tracy E. Miller

Print ISBN: 978-1-63220-566-7
Ebook ISBN: 978-1-63220-982-5

Printed in the United States of America

Contents

Foreword

Connect school to students' homes? Teachers make a real connection with their students' families? There are so many reasons to do it—and so many reasons not to. Why should we? Because making the abstractions of mathematics and science and history meaningful requires us to embed that teaching in the prior knowledge and concerns and interests of students. Contextualizing instruction—connecting teaching to who students really are—can transform the bored student into an eager one, transform resentment into relationship, transform passivity into problem solving. But how can teachers know who their students are? Certainly by listening to them. And by listening to their parents.

A teacher these days is likely to see a classroom of faces unlike her own, often speaking languages not her own, living lives that are unknown to her. The children who most need the school-home connection are likely to be those whose parents are the most shy about making approaches to school, the least understanding about what teachers do and why, the most puzzled about how they could help in the education of their children. And the hardest for the teacher to approach.

The research evidence is clear—family involvement is a crucial element for effective schools. Teacher and parent working together provide a continuity of concerns and activities that envelop the student in clear goals and rich assistance. Knowing the family means knowing the child in so many more dimensions and allows a teacher to individualize the activities and assistance and challenges that will foster intellectual and social development.

But there are so many reasons not to. Everyone has too much to do. The days are too long already. We don't know how to connect. We don't know how or when or what to begin with. And it's probably not worth the effort anyway.

All of those concerns will vaporize by the time you turn this book's last page. The authors, Kyle, McIntyre, Miller, and Moore, conducted an invaluable research program of five years for the Center for Research on Education, Diversity & Excellence (CREDE), exploring procedures and effects of a rich program of school-family connections. Their work provides a national model for improving education in diverse communities. These authors—teachers and researchers, using liberal quotations from families and students—teach us the joys—yes, the joys—that connecting with families can bring to the teacher and the students. And the pleasures of more authentic relationships with students that we wanted when we chose teaching as a life. But more than that, the authors tell us how to do

it, drawn from their own rich experiences in school-family connecting. It turns out that there are many ways of beginning to connect; and many ways to continue it—enough to spark the reader's own creativity and to inspire us all.

<div align="right">

Roland G. Tharp
Director
Center for Research on Education, Diversity &
Excellence (CREDE)
Santa Cruz, California

</div>

Preface

Why reach out to families? Most teachers know that connecting with families would reap many positive results, but they struggle with how to make the connection. Perhaps at no other time in our society have we been more aware of the need for teachers and families to work together in support of children. We have become increasingly aware that far too many children feel alienated, lonely, and angry. The message seems clear: The time to establish caring connections is now. We simply can't afford the potential cost of waiting.

This book is based on a five-year study in which we worked closely with the families of our students. Through our work, we have come to believe all parents care about their children and want them to learn, and we believe they want better for their children than they have for themselves. Many see schools as the "ticket" for their children's entry into middle-class life as well as the chance for them to grow into independent decision makers. What some parents often do not know is how to help their children succeed in school. Some may have different goals for their children than the schools have. And, since many parents had negative experiences in schools themselves, they may feel uncertain about how to ask for help and often unwelcome when they do. We believe it is the responsibility of the schools to find ways of reaching out and making connections, yet we also recognize that this means identifying and overcoming the barriers that have impeded such efforts in the past.

Time is a barrier that must be addressed. Teachers are already overburdened with expectations to teach in new ways, participate in curriculum renewal, and help all students achieve at high standards. Raising expectations about connecting with families is not realistic without a corresponding revision in school- and district-level policies about teachers' time. Past practice and long-held assumptions have created barriers as well. Traditionally, we have viewed schools and teachers as holding the knowledge children must learn. Family knowledge, especially about experiences and skills not typically included in the curriculum, has been ignored or even viewed as a deficit in children's readiness for school. Reaching out to families, then, will be meaningful only if teachers overcome this barrier and decide they have much to learn and families have much to teach.

Perhaps the most challenging barrier is acknowledging that many teachers would face personal challenges in the effort to connect with families. As long as the families "look like" their own, this might not be such an issue. But, teachers will need to think deeply about how they would respond to this question, "How comfortable do you feel with

people who are not like you?" The families of children in our nation's classrooms reflect differences in many ways: ethnicity, class, language, sexual orientation, religion, and cultural practices. While no one can know everything about these differences prior to getting involved in connecting with families, beginning the process requires that one have an attitude of respect for and appreciation of differences and a willingness to learn more.

We believe this book can be a wonderful resource for elementary and middle school teachers interested in building positive and strong relationships with their students' families, particularly teachers whose classrooms reflect a diverse student population. It is for the teachers interested in creating more meaningful classroom instruction that reflects the knowledge children bring with them from home. Principals, other district-level administrators, and parents will also find value in this book through the tips for providing support, resources, and time. The detailed, comprehensive examples of ways in which teachers can reach out to the families of their students include some that take no more time than writing a quick note and others that suggest more comprehensive change efforts. In each case, however, the book provides enough information to guide the teacher, yet allows for necessary or desired modifications. The entire book is applicable to practice.

This book is organized for teachers to use as they need it. We expect some practitioners to try out some strategies and not others, and to adapt strategies to meet the needs of their own students and situations. Yet, the book is very carefully orchestrated to reflect the cohesiveness of the ideas. In Chapter 1, we outline our vision and provide background that supports the ideas in the book. In Chapter 2, we begin by expressing the necessity and the strategies for building trust with families, for without trust, none of the family involvement attempts will be successful. Trust building requires respectful and open-minded attitudes about the families of our students, and we begin by sharing ways we have developed these attitudes ourselves. In addition, we believe that trust is essential for maximum student achievement, as the disposition and will to engage in academics is often a result of positive relationships.

Chapter 3 deals with communicating, in positive ways, with the families of our students. We provide numerous examples of how elementary and middle school teachers communicate with families in innovative ways that invite participation. Our examples illustrate how we help parents help their children, and how we build trusting relationships so they can ask for help when needed. Good communication is essential for students to reach their highest levels of achievement.

Chapter 4 deals with the implementation of Family Workshops, an exciting opportunity for teachers and families to meet in a social situation for academic purposes. We have found that these events work best when trust has been established, but that they also encourage further trust, if the families have a positive experience. As with all our strategies, our ultimate goal is higher student achievement, and this goal is reflected in the academic focus of these workshops.

Chapter 5 deals with Family Visits. In this chapter, we detail how trust is built through the visits, and how we as teachers discover information about our students that is critical to their academic and social

development. We detail steps teachers can take to initiate this very difficult, but worthy endeavor. We explore the academic benefits that result from this practice.

Chapter 6 extends from Chapters 2 through 5 in that we focus on instructional practices that are built from the trust, communication, Family Workshops, and the Family Visits we have developed with and for families. We illustrate example after example of the many ways that classroom instruction can be contextualized in the lives of our students, and how this pedagogy is illustrative of the professional teaching and student learning standards of several national organizations. Our goal is to maximize achievement through our work with families, and this chapter highlights how we do this.

Chapter 7 rounds out the book with examples of innovative homework ideas involving families. But we do not operate on the assumption that this, or any of the other practices we advocate, is easy. We show the struggles we have had with the issues and examine our own successes and failures in dealing with these struggles. It is our hope that practitioners select from this book what works best for them with the continued goal of doing this work to maximize achievement for all their students.

Knowing the challenges that this effort might require, why do we feel so passionate about its importance? The alienation of children and youth mentioned above provides a sufficiently compelling reason. We believe we have a moral obligation to apply our most creative and sophisticated thinking to this problem, and the ideas contained in this book offer several possibilities.

However, other reasons also motivate us. We believe, for example, that family connections provide teachers with a knowledge base from which to build meaningful, authentic instruction. Children engaged in learning that matters to them are likely to be more successful and to achieve at high standards. We believe they will be happier, more emotionally healthy, and more productive. Our hope is that they will also be more compassionate and committed to making the world a better place for everyone. These are lofty goals indeed, but we can think of no reason not to try and many reasons to make the effort.

ACKNOWLEDGMENTS ■

We are indebted to many who shared their experiences and ideas with us about reaching out to build stronger connections between schools and homes and who helped make the vision of this book a reality. Most important, we want to thank the children, families, teachers, and administrators with whom we have worked for providing us the insights to write this book. Their deep commitment to creating positive home-school connections for higher student achievement will help others interested in this work to do the same. We would like to thank the many teachers who contributed ideas for this book, including Ruth Ann Sweazy, Stacy Greer, and Maureen Awbrey. In particular, we would like to thank middle school teacher Vickie Wheatley for her work with families and her generosity in sharing her ideas and practices. We are grateful to elementary principals

John Finch and Carol Miller, and middle school principal Dena Kent for their inspirational work with students and families and their willingness to contribute their perspectives and examples.

We also thank the Center for Research on Education, Diversity, & Excellence (CREDE) for funding our research that resulted, in part, in the development of this book. We thank Cindy Gnadinger for help collecting data for this project. In particular, we want to thank CREDE's director, Roland Tharp, for his teachings and support for this important work. We thank Gracia Alkema and Rachel Livsey of Corwin Press for their belief that the perspective of this book was worthy and their understanding and assistance throughout the process of writing it. Mylantha Williams provided technical and clerical assistance when we most needed it, and we thank her as well. We truly hope that this book makes a difference for administrators, teachers, their students, and their families as they make connections and collaborate for higher student achievement.

Note: The research that led to the writing of this book was supported under the Education Research and Development Program, PR Award Number R306A60001, The Center for Research on Education, Diversity, & Excellence (CREDE), as administered by the Office of Educational Research and Improvement (OERI), The National Institute on the Education of At-Risk Students (NIEARS), U.S. Department of Education. The contents, findings, and opinions expressed here are those of the authors and do not necessarily represent the positions or policies of OERI, NIEARS, or the U.S. Department of Education.

The following reviewers are also gratefully acknowledged:

Mary Anne Burke
Adjunct Lecturer
College of Education
California State University, Sacramento
Sacramento, California
Adjunct Assistant Professor
Rossier School of Education
University of Southern California
Los Angeles, CA

M. Elena Lopez
Senior Consultant
Harvard Family Research Project
Cambridge, Massachusetts

Vivian G. Morris
Professor of Education
Department of Instruction & Curriculum Leadership
College of Education
University of Memphis
Memphis, Tennessee

Joann J. Sherman
Teacher
Plum Canyon Elementary School
Santa Clarita, California

Mary Ann Sweet
School Counselor
Tomball Elementary
Tomball, Texas

Germaine L. Taggart
Assistant Professor
Fort Hays State University
Hays, Kansas

RoseAnne O'Brien Vojtek
Elementary Principal
Ivy Drive Elementary School
Bristol, Connecticut

Deborah Waldron
Art Educator
Highland Local Schools
Medina, Ohio

Rose Weiss
Principal
Cambridge Academy
Pembroke Pines, Florida

About the Authors

Diane W. Kyle is Professor in the Department of Teaching and Learning in the College of Education and Human Development at the University of Louisville. She teaches curriculum-related courses and works with preservice and experienced teachers. She has coauthored *Reflective Teaching for Student Empowerment: Elementary Curriculum and Methods*, and coedited *Creating Nongraded Primary Classrooms: Teachers' Stories and Lessons Learned* and published in such journals as *Language Arts, Peabody Journal of Education, Journal of Education for Students Placed at Risk, Education & Equity, Teaching Children Mathematics,* and *Elementary School Journal*. Her most recent research project, codirected with Ellen McIntyre, is "Children's Academic Development in Nongraded Primary Programs," funded by the Center for Research on Education, Diversity, & Excellence (CREDE) at the University of California at Santa Cruz. An important aspect of this research has been the focus on teachers making connections with families through a series of family visits. Insights from this research provided the motivation for developing this book. Her future plans include more extensive work with teachers who want to use family visits as a way of building connections to support student learning.

Ellen McIntyre is Professor in the Department of Teaching and Learning at the University of Louisville where she teaches courses on literacy research and instruction and studies children's development in light of instructional contexts. She has published extensively, having coedited *Classroom Diversity: Connecting School Curricula to Students' Lives, Balanced Instruction: Strategies and Skills in Whole Language,* and *Creating Nongraded Primary Programs* and published in such journals as *Language Arts, Research in the Teaching of English, Journal of Literacy Research,* and *American Educational Research Journal*. Her most recent research project, codirected with Diane Kyle, is "Children's Academic Development in Nongraded Primary Programs," funded by the Center for Research on Education, Diversity, & Excellence (CREDE) at the University of California at Santa Cruz. An important aspect of this research has been the focus on teachers making connections with families through a series of family visits. Insights from this research provided the motivation for developing this book. Her future plans include more extensive work with teachers who want to use family visits as a way of building connections to support student learning.

Karen B. Miller has taught elementary school for eighteen years at Grades 1-4. She currently teaches a primary classroom of students aged seven to ten at Roby Elementary in Bullitt County, Kentucky. For two years, she has participated as a teacher-researcher on the study, "Children's Academic Development in Nongraded Primary Programs," funded by the Center for Research on Education, Diversity, & Excellence (CREDE) at the University of California at Santa Cruz. Making family visits during this time has enabled her to learn more about the students in her classroom and to make connections in her instruction. She has also served as teacher leader for the Kentucky Reading Project and Project READ Early Intervention where she provided intensive professional development for teachers on literacy and family involvement. She has presented at the National Reading Conference on home-school connections.

Gayle H. Moore recently retired after teaching elementary school for thirty-one years at Grades K-8. From 1991-2000 she taught in the nongraded primary program at LaGrange Elementary in Oldham County, Kentucky. Throughout that time, she participated as a teacher-researcher on studies related to the nongraded primary. She has coauthored a chapter in *Creating Nongraded Primary Classrooms: Teachers' Stories and Lessons Learned* and articles in *Language Arts, Peabody Journal of Education,* and *Teaching Children Mathematics*. She has presented at the annual conferences of the American Educational Research Association, the International Reading Association, the National Reading Conference, and the Holmes Partnership. Most recently she has participated as a teacher-researcher for the study, "Children's Academic Development in Nongraded Primary Programs," funded by the Center for Research on Education, Diversity, & Excellence (CREDE) at the University of California at Santa Cruz. She made visits to her students' homes throughout much of her teaching career, and for three years of the research project focused her visits to learn about the families' knowledge and use it to make instructional connections.

1

Connecting With Families

We were visiting the family of Becky, a second grader in an elementary school of 1,300 children in a poor rural county in Kentucky. We asked Becky's parents about Becky's interests, friends, and routines. We explained that we wanted to learn as much as we could about each student so we could best meet the children's academic, social, and emotional needs. The parents eagerly gave us information, watching carefully as we took notes. Finally, Becky's mother said, "I wish all teachers would do this. If Stanley's (Becky's brother) teachers knew him better, he'd be doing better in school."

"Yeah," sighed Becky's father. "He's just a number there."

Just a number. How many students are viewed as just a number, a vague face, another average kid? In today's large bureaucratic schools, teachers find it nearly impossible to meet the demands of their classes and know their students in ways that make each student an individual with specific needs and gifts. In the last few decades, schools have become larger and more diverse, and in recent years, classrooms more crowded with fewer qualified teachers. School violence is on the rise, and teachers, many of them with potential for changing lives, are opting out of the profession.

Clearly, schools have not kept pace with changes in society. Families have become increasingly busy, and they reflect structures other than the traditional two-parent, two-children prototype. New media and technologies emerge almost daily, affecting family time and communication in ways we had not imagined even twenty years ago. Even in the post-September 11th era of "nesting," a lack of family time persists (*Time*,

November 5, 2001). While societal changes in the last few decades can be viewed as positive and progressive, there is certainly no doubt that families have changed since mid-century. Yet, most schools have continued to operate in traditional ways by delivering instruction (perceived as "facts") that has little to do with students' present or future lives.

The disparities between the "culture of home" and the "culture of school" are widely known. With her groundbreaking work, *Ways With Words,* Heath (1983) illustrated how literacy discourse patterns in rural African American and Appalachian communities differed from those found in schools operating from white, middle-class standards. The differences between the school and community cultures disenfranchised the minority students and complemented the achievement of the mainstream community. Later work has shown us how differences in Appalachian speech (Purcell-Gates, 1995) and cultural experiences (Powell & Cantrell, 2001), Native Hawaiian ways of communicating (Jordan, 1985; Tharp & Gallimore, 1993), Hispanic language and culture (Moll, 1992; Valdés, 1996), and African Americans' storytelling and other language patterns (Delpit, 1995; Foster & Peele, 2001; Michaels, 1985) undermine the cultural ways of knowing of these populations and create school failure. These language structures are only one part of the many cultural differences that may impede achievement (Gee, 1990). Thus, the disparity between home and school continues to widen and the need to understand families becomes more urgent.

■ CONNECTING FAMILIES AND SCHOOLS: A VITAL GOAL

Creative minds are beginning to tackle this issue in different ways, and this book offers one—how to connect meaningfully with our students' families. We know that schooling in the twenty-first century *must* be different than it has been in recent decades.

Teachers must see their work as educating the whole student in meaningful ways, rather than merely as delivering instruction. To do this, teachers must reach out to students' families in ways not traditionally imagined, in ways that help bridge the ever-widening gap between home and school, in ways that help students realize they are known, cared about, and expected to achieve.

Leading researchers on family involvement have explored the impact of alternative, state-of-the-art ways of connecting with families. Epstein, Coats, Salinas, Sanders, and Simon (1997) and Hornby (2000) offer nontraditional ways of reaching out to create more "family-like schools" (Epstein et al., 1997) that focus on making each student feel included in school through work with families. This is a particular challenge with migrant children, students with gay or lesbian parents (Casper & Schultz, 1999), or others whose cultural backgrounds are different from schools. Yet, when schools focus on meeting the particular

> Gayle: I became much more interested in my students and their individual needs, interests, and strengths. Knowing more about them, I became a teacher of *children* instead of a *curriculum.*

needs of families, whether psychological or physical, and hold themselves accountable for student achievement, they can be successful at involving families (López, Scribner, & Mahitivanichcha, 2001).

Our work as teachers and researchers has led us to recognize that one of the keys to successful teaching and schooling is personal connections with students in and outside of school. Knowing the students' outside-of-school interests and passions, their families, families' jobs and interests, home routines, and literacy practices, and then using this information to connect in meaningful ways can have huge rewards in helping to construct happier, healthier, smarter kids.

Our perspective reflects our belief that the differences we find in families can be an asset to our classrooms and students' learning. Many other parent involvement books implicitly suggest that children and their parents, especially poor and minority families, have deficits that need to be remedied, and schools need to find ways to change families. We believe a more respectful approach is to recognize that families have differences, yet all are rich in knowledge.

> Gayle: I think it's all part of knowing the situation and what the child is going through, and of helping the other children accept and understand it. All of our experiences are different. Just because you live one way doesn't mean everybody does. We aren't trying to get everybody to be alike. We are trying to understand each other.

Although this knowledge may not mirror the school knowledge contained in curriculum frameworks, families are rich in traditions, experiences, and skills. Our book shares many ways of reaching out and connecting with families in order to learn what children and their families know.

IMPROVING STUDENT ACHIEVEMENT ■

Getting involved with families is not simply a feel-good message that attempts to raise students' self-esteem. We have larger purposes in mind. We want to communicate that viewing teaching in a different way can have considerable rewards for students academically. Our goal is to share how teachers can help raise the achievement level of each student in significant ways through close work with families.

This kind of work is not new. One of the leading and most significant attempts to change schooling to match home discourses and home cultural knowledge was the Kamehameha Early Education Program (KEEP). The primary goal of KEEP was to improve achievement of Native Hawaiian students by redesigning instruction so that it more closely matched the language styles of the children. Among the changes, literacy instruction was focused on *meaning* rather than skills, and it used dialogue (the *children's* style of dialogue) to discuss stories. Results showed much wider participation and comprehension development when teachers used the students'

> Gayle: I think I got the reputation for being able to handle troubled children because I would get to know the family and work *with* them to help their child to succeed in school. I don't think it was anything I did other than talk to the parents and try to profit from their experiences with the child.

discourses and cultural interests on which to build instruction (Jordan, 1985; Tharp & Gallimore, 1993).

Current work on changing schooling to reflect home cultural patterns is championed by Moll and González (1993) who use families' "funds of knowledge" upon which to build school curricula. "Funds of knowledge," first used by Vélez-Ibáñez and Greenberg (1992), refers to the various social and linguistic practices and knowledge that are essential to students' homes and communities. In some households, funds of knowledge might consist of craft-making and car mechanics. In another, it might be the Bible and canning. Teachers use a variety of ways to assess families' knowledge and build activities and curricular units around those topics. This not only serves to motivate children, but it "contextualizes" (Tharp, Estrada, Dalton, & Yamauchi, 2000) instruction in what the children already know, increasing the likelihood that the children will learn. In our book, the teachers have various ways of assessing family knowledge, and many examples of how they use this knowledge are described. Along with the studies mentioned above, we have found that when teachers and administrators get to know families in deep and personal ways, they begin to understand both the barriers to school success and how they can remedy the situation. They begin to see how to build on the successes of the community, which in turn may affect school achievement. Many of these studies have also reported increased parental involvement when teachers make these kinds of efforts.

Some family-involvement books seem to advocate parent involvement as the goal to be accomplished. Although we see this as a worthy goal, our book views reaching out and connecting with families as a means. Our ultimate goal is finding ways of making *instruction* in the classroom more effective for more children. We believe that teachers who know their children's families well are more likely to create meaningful, authentic instruction that will engage children and help them be more successful academically. This book offers suggestions based on large-scale parent involvement efforts as well as brief, short-term ideas that can be initiated by the classroom teacher and that take little time. Our goal is to provide a variety of ways teachers can reach out so all are involved with families in some ways. We do this by providing actual examples and tools from real elementary and middle school classrooms, tips on getting started, and numerous stories and vignettes.

> Karen: I think *understand* is the key word. It has really made me much more understanding as a person by looking at families and at the individual child. Understanding that he didn't get his homework done, but that's all right; we'll go from there and see what we can do at school. Mom's working two jobs; nobody is there to tell him to do it or to help. Whatever, it's made me more understanding—to know more about each child.

The work we describe takes time and reflection, two resources scarce in the lives of teachers. Yet, we propose ways to do this kind of work that is time, energy, and cost efficient. This book is not a "one size fits all" model for involving parents; we do not believe there is one way to do this kind of work. Instead, our book offers many alternatives that can fit the working styles of all teachers and the circumstances of all schools as they strive to improve student achievement.

CELEBRATING DIFFERENCES: ■
SEEING THROUGH FAMILIES' EYES

In this book, our focus is on how we as teachers can reach out to parents in ways that enable us to see school from their perspectives. It is not intended to get parents to do at home what we wish they would do, but instead it is for teachers and parents to share information that can improve instruction at school through the building of lasting, trusting relationships between homes and school. We view parents as experts on their child; they are our primary resources for understanding learners and knowing what and how to teach them.

Our perspective, which has come from years of working closely with families, is one of mutual respect. Yet, we know that at times developing respect is not always easy. We have found that many families have lives different from our own, and yet we have learned to see these as just that, differences, and in no way deficiencies or faults on the part of the families. In this way, our work is different from those who seek to change homes to look more like schools.

Since the fall of 1996 we have been involved in a research study of student achievement in elementary constructivist-based classrooms. We knew early on that to truly understand children's development, we needed to know children in a deeper, richer way, in a way that told us about the whole child, not just the school-academic side. Thus, our work took us into the homes and communities of the students we taught, and we began to look for more ways to build stronger relationships with the parents, guardians, or families (used interchangeably in this book). The families varied a great deal, and we had to learn how to view differences as just that, differences, and in no way, deficiencies, particularly because we knew that many of the families were dealing with major difficulties in their lives.

In our study, the families varied by race, economic group, and background. Twenty-seven percent of the children were African American or bi-racial and the rest were white. Forty percent were considered poor and rural and another forty-seven percent were considered working class and were either rural or urban. From this group, forty-three percent lived with a parent with less than high school education. Seven of the children lived in apartments, nine lived in trailers, and fourteen lived in single-family homes by the end of the study.

A pattern common across most families was that they all faced challenges in their personal lives that (for some) seemed to affect school performance. These challenges manifested themselves in frequent episodes such as hitting, throwing objects, swearing, and tantrums. Through our work with the families, we know that these children, in their young lives,

> Karen: My outlook has changed. My focus is much more child-centered. I look at this like a friendship. When you get to know somebody, it's a gradual thing. The more you do for your friend, the more they do for you, and it just grows and grows. I really see that in the relationships I've built with these families. You're not going to have the same relationship with every family. With some, there's more give and take; with some, less. You know those families and what they want for their kids, and you don't want to disappoint them.

had faced such experiences as the death of a father and subsequent remarriage of the mother, the death of an older brother due to "huffing" (breathing in fumes from a household item such as paint, glue, or air conditioner coolant for the purposes of intoxication), parents' divorce, changes in custody arrangements, an alcoholic parent, sexual abuse, and other such emotionally charged events. The most common challenge across the families was financial stress, or "making ends meet." The strategies we share in this book represent those we have tried with children who represent this group of wide-ranging exceptionalities.

Yet, there were also many examples of support for education as well. A common pattern of support in most of the families was the close connection the families had with members of the extended family. Many of the families were emotionally, and sometimes financially, supported by family members they saw or spoke with every day or nearly every day. Some lived with extended family members, or they lived near by, "up the road." When interviewing, it was clear that the families depended on one another for support (both financial and emotional) and company. Children knew their grandparents and cousins well and received love from several adults, not just their parents. It was clear that these other adults took on parental roles, often reading to the children, picking them up from school, or taking them to events.

In the study, the teachers and researchers read professional books for ideas on how to connect school with the lives of students, and we tried out a number of our own. Through the involvement of families, we began to see changes in our students that we had not seen before. Because of the changes we made in curriculum that were based on our deep knowledge of families, we also found results in student achievement. Like much previous research before ours (Johnson, 2000; Tharp, 2001), our research study showed us that for many of our students, achievement surpassed the expected, and we knew we were trekking across important territory. When we talked to other teachers, we found them skeptical but intrigued about what we had experienced. In our fourth year of this work, we decided to write this book.

We knew that developing positive, trusting attitudes with our families was a part of the success of this work. And we knew that with the right attitude, the major barrier preventing this work was time. Teachers are already overburdened with expectations to teach in new ways, participate in curriculum renewal, and help all students achieve at high standards. Raising expectations about connecting with families is not realistic without a corresponding revision in school- and district-level policies about teachers' time. Our suggestions will help teachers see connecting with families as an efficient way to teach, not a burdensome way, and they will help principals envision ways of supporting teachers' efforts.

In our book we deal directly with the issue of time by encouraging teachers to work differently, not more. This book contains examples from Karen and Gayle's classrooms, two authors of this book. It also includes examples from other classrooms with which we have worked, including Vickie Wheatley's middle school where she and her colleagues have been doing this kind of work. In addition, the book includes the perspectives of three principals who have made family involvement a priority in their schools: John Finch, elementary principal in a small town in the Oldham

County School district; Dena Kent, middle school principal in rural Spencer County school district; and Carol Miller, elementary principal in urban Jefferson County Public Schools.

WHY WE CARE ■

Knowing the challenges that this effort might present, why do we feel so passionate about its importance? It is because we have experienced, first-hand, the effects these positive connections have had on the children we teach. Gayle and Karen are elementary classroom teachers who teach many poor rural children outside Louisville, Kentucky. They have been participating in conducting family visits for many years and have sought to reach out to families in other ways as well. The other two authors, Diane and Ellen, are university teachers and researchers at the University of Louisville where they participated with Gayle and Karen in a national study of children's development in light of the students' home and family knowledge and practices. This study was funded by the Center for Research on Education, Diversity, and Excellence (CREDE). Through the study, we have discovered many ways that school works better when family connections are made. And as we write, we are continuing to explore possibilities of how to reach out as we talk to and read about others who are engaged in this work.

We know there are no guarantees and that students' problems and school issues are multifaceted. Yet, we know education through positive relationships is one way we can combat the alienation so many children experience today. Success at this kind of education comes from knowing our students as individuals and showing our commitment to them. In the fall of 2001, as we were completing this book, Karen received a poem from a former student she had had the previous school year when he was in second and third grade. We think it illustrates this kind of success:

Do You Know My Teacher?

By Joshua Clark

Do you know my teacher?

She is the one with the big smile

The one who cracks up over my gross jokes

Do you know my teacher?

She is the one with the great imagination

The one who taught me to give from the heart

Do you know my teacher?

She is the teacher with the wonderful laugh

The one who has a great sense of humor

Do you know my teacher?

She is the one who gives more than we know

The one who showed up at my ball games

Do you know my teacher?

She is the teacher who came to school sick

The one who gave me a special book for my trip

Do you know my teacher?

She is the teacher I will never forget

The one who understood and loved me for two magnificent years

Do you know my teacher?

She is the one that touched my heart

The one who I call Mrs. Miller

Receiving a poem like this from a third-grade boy can come only when we know our students intimately and show how much we care. In this book, we share many ways we have learned to show care and build trust. We share multiple ways we reach out to families to build positive relationships that enhance academic achievement.

2

Building Trusting Relationships

No amount of effort toward improving home-school relationships will be effective without trust. Our students' families must trust that we truly want for their children what we want for our own children. We must invite trust that helps us become partners with families in improving education for the children. Building trust takes sharing of ourselves, seeing families' lives as complex as our own, obtaining and valuing the knowledge and opinions of the families, and working together toward common goals.

EXAMINING OUR ASSUMPTIONS ■

The well-known difference between poor/working-class families and middle-class families in parental attendance at school functions has led to widely held myths. Many teachers interpret parents' absence at school functions or unfinished homework as a lack of concern for education on the part of parents. We often hear teachers complaining about parents with phrases such as, "they don't care," "they can't read," or "they don't know how to help" without evidence that any of this is so. Yet, recent reviews of research on parent involvement suggest that a large majority of parents want to be involved in their child's education (Epstein, Coates, Salinas, Sanders, & Simon, 1997; Hoover-Dempsey & Sandler, 1997). However, many families do not know how to get involved, and it becomes the teacher's responsibility to reach out.

Essential to positive home-school partnerships is not only knowledge but also attitudes teachers have toward families. In our work, we have uncovered some of our own biased beliefs toward families and have learned to deal with the discomfort that comes with working closely with people who are not like us. Karen admits:

> Gayle: My biggest surprise was how intimidated parents are by teachers and schools. It had never occurred to me how intimidating we are—teachers, principals, even the building is intimidating to a lot of parents, particularly parents who had bad experiences in their own educational background.

> I remember thinking that if a parent did not come to a conference, they didn't care as much as they should. But it's not that they don't love their kid or don't care; there are a lot of circumstances that might be present with some of these families. I feel awful that I felt that way.

Middle-school principal Dena Kent says that this view is common and long-held among teachers. She explains that,

> Teachers come with preconceptions about students and families, and therefore may not be as open to the positive or potential about what is there. Teachers can view their work in a territorial way, and this can become an obstacle.

In her work with teachers, Dena says she has had to delicately invite teachers to become more involved with families. She understands their concerns and has learned to "see it in their eyes" when she makes suggestions about working with families. She says, "You see doubt. You see the chin drop, and you know you have a difficult task ahead of you."

There is no doubt that taking this step toward involving families is difficult for many teachers. Many teachers' lives are different from those of their students' families, making communication across "borders" awkward. Reaching out to families, then, will be meaningful only if teachers overcome this barrier and decide they have much to learn and families have much to teach.

■ TEACHERS ARE PEOPLE, TOO

For many families, teachers are a mysterious group to be (at times) avoided, tolerated, confronted, or even manipulated. The gulf between school and home is often wide, with little contact outside of the classroom and rarely, if ever, on topics unrelated to student progress or behavior. Yet, in our work, we have found that whe parents and children see us as people with lives outside school, families, interests, concerns, and struggles, the gap between school and home

can be narrowed. When they see us as humans, they can begin to trust us, which is critical for building the kind of respectful relationships necessary for student success. In a visit with one of Karen's families, a mother said, "I think it's really important for any kid to see their parents, their mom or dad, socializing with their teachers outside of school. It lets them know someone else really cares about them." When asked what impact this out-of-school contact has had, she said, "I feel like I am really part of the school. . . . I wasn't part of school with Jose [older brother] when he was younger."

> Karen: You have to consider educating the child in partnership with the family. We have differences, but the common goal is to educate the child. We have to establish partnerships where we can learn from each other. A lot of time there's one-way communication—teacher to family, but we need the opposite—family to teacher. And, you have to make it interesting for the kids, make it all come alive, be fun, and not boring.

SHARING STRUGGLES ■

One way we can begin to be seen as humans is to share our lives with our students' families, particularly when there are similarities between them and us. Sometimes this might mean sharing similar struggles. For instance, when one mother discussed her great difficulty with being a single parent on welfare and without a job, Ellen told her about her sister who had been recently left by her husband of fourteen years. She had three school-age children and no job and suffered great trauma and struggles. With another parent, Ellen shared that a young child she is helping to raise has difficulty going to sleep at night, and she described her frustration at being controlled by a three-year-old. Those parents both said how they appreciated hearing these stories. They helped the mothers feel less alone with their struggles and provided hope that their lives might get easier, too.

On one family visit, Karen shared that her own son struggled with reading, a surprising fact from an excellent reading teacher! How enlightening it is for parents to realize that a child's learning problem is not the fault of the parent. On one of Gayle's visits, a mother told Gayle that she had always struggled with reading, and Gayle told the parent that her niece who had had similar troubles had bluffed her way through school. Gayle explained that much later her niece was found to have an undiagnosed but correctable eye problem. Her learning improved, but she was never able to make up for so much lost time. The vigorous nods and questions that followed these conversations indicated that each parent saw us as real people with struggles and concerns outside the classroom. It taught us all that despite class differences, many of us have similar lives. Gayle summarizes:

> It starts with the teachers; we have to show ourselves as vulnerable, let the family know that we are human beings. We are not this superior all-knowing person who is going to teach their child. We

are just human beings trying to figure out how this child learns and how to teach. . . . Let the family know you don't have all the answers. Say, "Well, I don't know that, but I will try to find out." Let them know you aren't above them.

> Karen: Looking at it from a parent's point of view, it is just exactly what I want. I want every teacher to be that concerned about my two kids.

It starts with the teachers, who must make the first effort to reach out to families. If you let parents know you are not "above them," as Gayle puts it, you will help eradicate some of the intimidation some parents feel around teachers. In fact, we were surprised to learn that so many parents of all social classes and ethnic groups feel intimidated by teachers. Parents know teachers have incredible power to make their children's lives wonderful or miserable. Ellen remembers taking a child she cares for to a school skating party and feeling extremely nervous about making a good impression and showing respect for the teachers. She remembers being conscious of writing this book and having this experience at the same time and thinking, "If *I* am so nervous (as one who knows a lot about schools, teachers, and families), how must others feel?" Showing ourselves as vulnerable and recognizing that some parents feel intimidated can go a long way toward building trust.

■ SEE AND BE SEEN

Being visible in the community outside school is another way of showing families that you are real. All of us have been to at least some of our students' ball games, performances, or celebrations. The thrill for the students of seeing their teachers outside of school and there for them was evident (even when the children pretended not to notice). And simply seeing their teacher in a self-service laundry or grocery store can help families see teachers as real. Diane and Gayle attended the ball games of some of the students, and Ellen attended a church ribbon-cutting ceremony and the town's famous homecoming parade. Gayle remembers more than once a child running the length of the grocery-store aisle to speak to her when seeing her unexpectedly. Another teacher we know, who didn't live in or near the community in which she taught, took her laundry to school once a week and visited a self-service laundry in the late afternoon in an effort to be available for her students' parents in an informal place for a legitimate reason.

Another fun and interesting adventure that teachers can have is to make a visit to the school's community with the eyes of an anthropologist. Go into the community, make drawings and maps of what you see, eat at a local establishment, talk to people who work in the community (postal workers, a gas station attendant), and "walk the walk" of the students in the school. JoAnn Archie, another teacher who worked on the study, uses this term when describing how she walks on the streets that take children from school to home so she can see the neighborhood through their eyes. JoAnn has written about her experiences (Freppon, 2001) visiting her school's community prior to beginning to teach there. As an African American woman teaching in a working-class white neighborhood, she did not know what she did not know about her students' families. Her principal took the teachers on a field trip

through the neighborhood before school began, and she realized she had harbored the same assumptions about her white students that she knows some white teachers hold about their black students. Sometimes, until we experience a culture other than our own, we do not realize the prejudices we hold.

Elementary principal Carol Miller values getting out into the community and believes principals can find ways to help teachers make important connections with families through neighborhood visits.

Elementary school principal Carol Miller said:

> When I first became principal of McFerran, one of the first things we did was put all the teachers on a bus and drove out to all the neighborhoods [from which the children were bused]. We just got out as a group, and we walked through the neighborhoods. It was summer, and the kids were out playing. The teachers got a feel for the neighborhoods, and also they got a feel for how long the kids were on the bus. In the McFerran neighborhood, we walked, and people would come out on the porch and talk to us. We heard, "Oh that was Miss Jones, my second grade teacher." We talked about the historical significance of the neighborhood, the architecture, the economics, where most of the people worked, what kinds of jobs they held. We could see the kids coming to school, which ones had to cross over the railroad track, and so on. We talked about the history of old McFerran. The school was established because Mr. McFerran got a horse and buggy to pick up the kids, because the boys were always catching the train and going downtown fishing. Then we walked through a housing project called LaSalle on Algonquin Parkway. It was really a neat feeling. Kids were saying, "Come here, come meet my Mama." Some people invited us in, some just were tickled if we came up on the porch. It was really nice.

Carol Miller's school is populated with children born in countries other than the United States, and many speak English as their second or third language. The differences between the students there and the teachers makes it even more vital to "see and be seen" in the community.

When Diane and Ellen taught preservice teachers, they expected their students to make the kind of trip that principal Carol Miller described. They expected the students to participate in the following:

- Drive throughout the neighborhood surrounding the school.
- Walk several blocks around the school.
- Make a map of the neighborhood, identifying resources within the community that could be tapped into instructionally.
- Identify problem areas or potential barriers in the neighborhood to successful home-school relationships.
- Interview someone who has been working in the neighborhood for at least ten years.
 - Ask: What do you consider the (school's name) neighborhood?
 - What are the boundaries? How did you decide these boundaries?

- What do you know about (the school)? What are your perceptions?
- What resources or barriers exist in the community for the young people attending this school?
- Interview a parent of a child in the school and ask the same questions.

Our colleague at the University of Louisville, Hope Longwell-Grice, builds on this activity in her social studies methods course for teachers. After the students explore the community of their assigned student teaching school, they develop a unit of five to ten lessons that could be used by faculty at the school. Suggested lesson topics and activities include: defining community, examining the physical characteristics of the community, looking at the groups and institutions that make up a community, exploring identities of community members, and implementing a community action project. The goal in these activities is to try to experience the community as the children who live there do, teach students to look at their own community, explore their identities with it, and do something good for it. Students and families will appreciate your interest and work when they know where you have been and with whom you've spoken. You can show them your maps and have them help you make better ones!

> "Getting parents into the school building can help them overcome barriers they may have had based on their own school experiences. As I said, this is a community where grandparents and parents went to this school, and if they had a bad experience, it will impact their perspectives."—Middle school principal Dena Kent

Principal Dena Kent describes her school's Community Learning Center, which relies heavily on parent participation and input. Her rural community has few social opportunities, so she has tried to make the Center a place where adults want to gather. The Center was funded by a federal grant, and its goal is to develop social and academic programs the community needs. The parents involved surveyed community members and from that information developed a sports club and a computer program for students and their parents. The Center is in the school building, and it operates before, during, and after school hours.

At the Center, teachers and families work together on common goals, which is one of the most effective ways of building trusting relationships. When people in any circumstance share time and resources for a common good, they learn to care for one another. Roland Tharp and his colleagues (2000) call this "joint productive activity" and suggest that through joint work with an authentic product or goal, relationships develop in positive ways. Vera John-Steiner (2000), who studied the collaborative efforts of famous academics and artists, extends this by saying that without trust, true collaboration cannot happen.

For parents and teachers, what better way to build trust and positive rapport than working together to do something good for the children? And it is not necessary to have a Center like Dena Kent's. Simple ideas such as holding a bake sale to raise money for a field trip or collaborating on lesson plans and teaching can create bonds that then further the work of the participants. In Chapter 4 we share many ideas for bringing families together to work toward a common goal, and in Chapter 6 we discuss how

some parents have helped create the curriculum and implement instruction in their child's classroom.

PARENTS ARE PEOPLE, TOO ■

Of course, the parents or guardians of our students are people, too. They are not simply the caretakers of our students, but people with complex lives beyond their children. Sometimes we neglect to truly see what many of our parents or guardians are dealing with outside of their children's (our students') lives. We need to consciously realize that parents have their own parents and siblings to worry about, work issues, economic issues, scheduling difficulties—essentially the same problems *we* have in our lives. When we remember this, and try to see through their eyes, we can make adjustments in our attitudes, expectations, and interactions with families as necessary. When circumstances in families' lives are difficult, new issues arise for us as teachers. We must keep all information confidential, and we must react in a way that we would want our own children's teachers to react. As Gayle said, "We aren't trying to get everyone to be alike. We are trying to understand one another."

Gayle had one student, Stevie, with whose family she had tried repeatedly to schedule a visit without luck, and when visits were scheduled, they were canceled at the last minute. Stevie's mother had remarried after her husband had died of cancer two years earlier. The mother had been regularly confrontational with Gayle, challenging what was taught, why spelling books were not used, and so on. But Gayle continued to ask if she could visit. Then one day, the mother surprised us all by calling and asking Gayle a question, making a point of saying that she was not complaining. During the call, Gayle asked again if she could visit, and the mother agreed if Gayle could come that day. During the visit, the mother described problems she was having with her son. She said Stevie resented her remarriage and that he missed his dad a lot. She explained that Stevie resented her because he wasn't there when his dad died. She had chosen to have him stay with relatives when his dad got sick in an effort to protect him. At this point, the mother broke down and cried, saying she regretted this decision. Gayle sympathized that this must have been a difficult decision and that we can never know what to do in these circumstances. Stevie might have ended up feeling worse had he witnessed his father's slow death. The story helped Gayle understand her student at a new level. This kind of conversation would never have occurred without trust.

> Gayle: It's important to understand how various people show their caring and love for their children, and it's not always the same. It's not always *my* way.

HOW DOES TRUST DEVELOP? ■

What contributed to this trust building? How did the relationship between Gayle and the parent move from confrontational to intimate? Gayle believes that it was partly her perseverance in attempting to connect with

the family. She did not give up after one "no"; she continued to ask (in gentle and encouraging ways) if she could visit until the parent was ready. She also maintained a noncondescending attitude, one that is respectful of the parents' issues and complaints (even when she did not agree with the parents' suggestions).

Most important, Gayle treated the *parent* as the expert on the child (not herself). When we see parents as experts and seek to learn from them, they feel valued. When a person feels valued by another, trust can occur.

Simple acts of kindness can create bonds with families that may not have been created otherwise. Karen recalled sympathizing with a parent whose father was dying. The mother of her student Chelsea had called her to explain that the student might be missing some days and that she might come to school tired because she was visiting the hospital regularly. Karen assured the parent that she should do what needed to be done and that there would be no pressures from school. The parent then asked Karen if she would tell Chelsea's sibling's teacher about possible absences, and Karen obliged, relieving the mother of that obligation. Karen also invited Chelsea to make a giant card for her grandfather. For Chelsea this was a significant event during that school year because she put a lot of time and creativity into the task and even worked on it at home, making the giant card a letter. After this correspondence, Karen and the parent communicated regularly, with the parent showing surprise and appreciation for Karen's concern.

■ NO DEAF EARS:
DEALING WITH THE HARD STUFF

When trusting relationships happen between teachers and parents, when families learn that we care about the family, not just about the student, a new responsibility arises. We have been in situations where we knew no food was in the house and a child was hungry. We found ourselves interviewing parents who were complete nonreaders and others not fully capable of understanding our questions. We faced racist and homophobic remarks from families and other community members. We had always to think on our feet and make decisions we hoped were best for the child in the long run. We have alerted the schools' Family Resource Center director for food, and have communicated with older siblings when a parent was unable or incapable of communicating with us. We have refused to comment on racist or homophobic remarks, but continued our interest in working with the family. When a mother of one of Gayle's students expressed her desperation about losing her job, Gayle could not simply say to her, "Oh, I am sorry you lost your job." She had to think whether there was something she could do, someone she could talk to (which is what she did). When trust happens, we must take on the new responsibility that we might have avoided in the past.

This can cause some problems in a school building. This sets a new or different standard for teaching that some colleagues might not like. Teachers who take up this challenge may not be understood or appreciated by others. They may be viewed as a "rate buster" in labor terms—one who shows that more can be done than what has been done in the past, raising

the standard of what might be expected of everyone. Teachers who take on this kind of responsibility may be ostracized by their peers. Thus, teachers must deal with change of this sort quietly and delicately without insisting that others get on board.

Middle school principal Dena Kent makes the point that family involvement with the community usually develops gradually as teachers either identify parents' skills that can be used in the classroom, or make closer connections between family involvement and curriculum content. She says,

> One way an administrator can support family outreach efforts is by supporting teachers who do this work without singling those teachers out alone, but by sharing the positive efforts of all teachers (of which family involvement is one). This way, when the work is acknowledged, it can be respected and appreciated by others in the building. Others will be more likely to inquire about the work and begin to seek ways they too can reach out to the families in their classrooms.

> Teachers can take small steps at first. First, I want my teachers to see what a great opportunity it is to have parents come in the evening for workshops [explained in Chapter 4]. And then we can do student-led conferences [Chapter 3], and the next step might be family visits [Chapter 5]. You have to logically make your choices, taking into consideration where people are at the moment. In some schools you may only have one or two teachers ready to use these experiences in ways that would be worthwhile.

KNOWING OUR STUDENTS ■

Establishing better relationships with families means we will get to know our students more deeply. But it works the other way around as well. If we begin to find out more about our students, we will invariably learn about their families as well. But if we do not make the effort, we can discover we know very little about them.

When Karen and Ellen directed a summer literacy institute, a colleague asked all teacher participants (35) to make a list of their students from the previous school year (2 weeks ago for most). After a few minutes, she said, "Now I want you to write something by each student's name about that child's out-of-school life." Well, this was not easy! Most teachers bemoaned the fact that they could not even recall all twenty-four or so of their students, much less something about their out-of-school lives. Many admitted to knowing only one or two students' out-of-school interests, and they had learned them incidentally. Karen, however, told Ellen later, "If it hadn't been for all my recent work involving families, I would never have been able to complete this task. Instead, I could list something for nearly every student."

How can we get to know students better? Karen and Gayle and the other teachers with whom we have worked have provided numerous ideas that are described throughout this book. In this chapter, though, we would like to focus on the ways principals get to know students as well. Principals John Finch, Dena Kent, and Carol Miller all believe it is their job to get to know students and their families as best they can. John gets to

know his students by making a call to many of the parents during the school year.

Carol reads every student's report card at least once during the school year. Examples of the kinds of comments she has made (with names changed) include:

Awesome attendance! Thanks, Mrs. Smith for seeing that John gets to school each day. Good attendance is critical to student success and we appreciate your support.

Mrs. Jones, I know DeVon has been ill a lot this semester and it has made a difference in his schoolwork. I hope we will be able to keep him healthy next semester so he can get back on track.

Jessica has turned in all her homework this grading period! Thanks for supporting Jessica as she completes her homework. She is becoming a very responsible and independent young lady!

Carol also wants to know what comments the teachers make and how the children are doing. She makes a point of talking with parents when she sees them about the child's report card.

Another elementary principal we know in Louisville examines samples of students' work at the end of every week, making sure she sees all children's samples quarterly. She meets with the students' teachers about the students she is concerned about to discuss possible barriers and better support toward higher achievement. This principal holds herself and her students accountable for student learning. It has paid off. With many of her students designated as "at risk" for school failure (99% of her students are on free or reduced lunch and there is a large population of homeless children), her school test scores surpassed the expected, and student achievement growth remained higher than average for years.

In both Vickie Wheatley's and Dena Kent's middle schools, some of the teachers use "Agendas" (described in Chapter 3), which help with communication to and from home. The students are expected to write academic concepts learned and assignments in the book, but some have taken it to "a higher level." In Dena's school,

Some of the kids have written in their agendas to their parents that they didn't understand what was taught at school. Some use it to organize their out-of-school lives as well. Some of the adult research about women say that their agendas look different from men's because they have notes in there about their personal lives as well as work. I see kids doing that too. Those involved in extracurricular activities, you see them recording that. Or they will record other kids' birthdays, that sort of thing.

Dena also has a "principal's round table" each week in which she invites several of her middle school students to sit down with her in a group to discuss how things are going in the school. "We talk about testing, curriculum, the discipline plan, vandalism, what is working, what isn't."

PARENTS AND GUARDIANS AS EXPERTS ■

Letting the families know that you recognize them as the experts about their child can also encourage trust. As teachers, our goal is to gain as much information about each child outside of school as possible in order to better meet their needs inside of school. We view the parents as experts and seek to learn from them—about their child's routines, literacy habits, interests, social relationships, and family knowledge and skills. We try to meet face to face with each parent, but this information can be accessed through a survey as well. We begin by asking these questions, adapted from Kentucky's Early Learning Profile (KELP; Kentucky Department of Education, 1992). An example of a KELP from Karen's classroom is shown in Box 2.1.

Box 2.1
Conversation

Parent/Guardian Questionnaire

1. What have you done as a family member this summer that became a learning experience for _____?
 Vanessa reads to mom. Brother reads too. Reading is very important to mom.

2. What do you notice that _____ can now do that he or she could not do when school was out last spring?
 Reading better. Dad helped her out a lot last year when he was here. Doesn't skip over words when they aren't right. Fewer backwards letters.

3. What kinds of experiences has _____ had in:

 Reading: *Dr. Seuss books; bought tons of different books from book clubs; likes to read.*

 Writing: *Practiced ABCs some.*

 New social experiences: *Grandma has a new pool and we used that a lot.*

 Music: *Recognizes noises on records (she calls it a flute)*

 Math: *Played with calculator a lot; calculated pages read from books.*

 Art: *Coloring*

 Science: *Worked with chemical to put in pool; she'd know when to put them in.*

 History/geography:

 (continued)

Box 2.1 Continued

Physical fitness: *Tried to learn to roller skate; swim; beach ball in pool; trying to ride a bike; taking up bowling*

4. How has _____ changed the most this summer? (Follow up with question about new interests.)
Reading; concentrates better; book reports have helped; spelling is weak; math is great; got it down to a tee

5 What goals do you have for _____ this school year? What do you want _____ to learn and be able to do this year?

Child Questionnaire

1. What did you do this summer that you like best?
Swimming in the pool; learned to swim 1-1/2 lengths; learn to do front flip, back flip; stand on head

2. What did you learn this summer?
To draw fish; copied from dad; getting into art

3. How are you smarter now than when school was out? (Follow up with question about new interests.)
Reading, but I was an excellent reader in Miss Steven's class too. Running.

4. What do you want to learn about in school this year?
Are commercials true?

5. What do you want to learn how to do in school this year?
Flip backwards into the pool; gymnastics; cheerleading

We take careful notes during these visits, writing down exactly what we hear. We then read back to the parents what we've written so they have an opportunity to change what has been written about their child or to add something, if they wish.

We attempt to build on the information in the classroom, which is sometimes a challenge. But finding a way to get a child needed help can go a long way toward building lasting relationships. In one of the families Ellen visited, the child, Amber, was exceptionally good at art. Her mother was concerned because the school did not offer art lessons until fourth grade, and she worried that her daughter would lose her talent. After some discussion Ellen decided that though she could not teach Amber how to *do* art, she could teach her *about* art. For nearly a year, she held weekly small group lessons focused on biographies of great artists, helping the children construct understandings about art through biography. On one visit to her home, Amber's mother expressed her gratitude for these lessons, saying Amber loves them and is "trying to copy their (the artists) styles."

Of course, most teachers do not have this kind of help. But there are other options. Teachers can invite children into other classrooms for part of a day, or ask the school counselor to assist in finding the child the services needed. Sometimes, with just a bit of effort, teachers can open a whole world for a child that might not have been possible otherwise.

SUGGESTED STEPS ■

To summarize the ideas in this chapter, we would like to make suggestions for what to keep in mind when interacting with the families of the children you teach. These key points will help you and your families build the mutual trust necessary for high student achievement.

- Share yourself, particularly those things about you that you have in common with the family member with whom you are connecting. Share things that happen in your life, and they will share these things with you; share photographs and other mementos.

- Show up in the community, in places your families are likely to be.

- Show interest and concern in the lives of your families. Let them know you see them as more than your students' caretakers.

- View the child as more than just a student; he or she has interests and needs outside of school as well.

- Plan some time each week in the community of your school if you don't live there, even if this means a short drive around the block after school. You could plan your exercise walk in that neighborhood or just simply shop at the drugstore in the area when you need something.

- Ask parents, "How is everything with you these days?"

- Invite parents to share what they know about their children in a survey or interview.

- Ask parents regularly, "Is your child getting what he [she] needs?"

- Invite parents to share their opinions about the school year through a survey or interview.

SUMMARY ■

In this chapter we emphasized the importance of building trust with families, for without trust, the other activities and strategies may be fruitless. However, it is also *through* the activities that trust is built, so getting started toward reaching out to families does not need to be postponed until we feel comfortable. We can examine our assumptions, share ourselves, be seen in the community, and plan activities with parents while the trust is being built. Start small and see what happens.

3

Strategies for Enhancing Communication

Establishing a positive communication link between the school and the home provides an important foundation for sharing knowledge and insights about individual students. In this way, teachers and parents become a team with the common goal of supporting students' achievement and helping them feel known and valued.

For many students and their families, having a note sent home by the teacher is cause for great concern. Certainly it must contain bad news—poor academic performance, misbehavior, trouble getting along with others, or poor work habits. Many teachers even refer to these as "sad notes."

Certainly, we're not suggesting that parents don't need to know about school-related problems. However, written communication can serve many purposes, and using it for positive news can put a spin on traditional written communication. With strong positive communication ties established, it becomes easier to address student problems if they do occur and then work together on solutions.

In this chapter we provide several examples of how elementary and middle school teachers communicate in writing to families at home. In some examples, the teacher or principal does the writing, and in others the students themselves do the writing. In some cases, these activities require two-way communication *from* home as well as *to* home, and in others, they serve only as information. In all cases, teachers are sensitive to families with low literacy skills or those just learning to speak and read English.

Figure 3.1
Postcard

■ POSTCARDS

Before school starts, some teachers send postcards to welcome each child to their class. They might introduce themselves, share something about the upcoming school year, and write that they are looking forward to meeting the student. Postcards can be sent at other times of the year as well, for example as a thank-you, to send a note from a trip, or simply to say hello.

Teachers may want to write in words they think their students can read, and for emergent readers, using primary-grade language can provide an opportunity for parents to read to the children and help them identify some of the words. When parents do not read English well, teachers may want to find a word or two in the family's language just to say hello or thank you. So a postcard might read:

> "Hola! I am Elena's teacher this year. I am writing to welcome her to school. I look forward to meeting her and the family. I hope I get to know all of you this year. See you in August. Adios! —Ms. Teacher."

This shows respect for the family and their language and invites the parents to find someone who can read the rest of the message to them.

■ NEWSLETTERS

Parents want to know as much as possible about what their children are doing in school. Weekly or monthly newsletters help keep parents informed and can also be a way to suggest how they might become more involved in the classroom and school. One kindergarten/first-grade teacher we know, Maureen Awbrey, gives the class's weekly newsletter a heading that reflects the theme of her classroom each year. One year it might be *Rainbow Ramblin's,* because the class is "the

Figure 3.2
Newsletter
Excerpt

Rainbow Ramblin's

News From "The Rainbow Connection" November 9, 2001

NEW NAMES—In connection with the pioneer study, we are taking a new name. The names were found in our pioneer storybooks. The children worked in groups to find them. They will choose a pioneer name that we will use while we study and live the pioneer life. Please go along with this.

REPORT CARDS—The report cards are coming home on Friday. Please look them over, fill out the parts for you to write in, sign it, and return the following Monday. I will send you a copy to keep. I am including a check sheet, which I have made up. You can keep it. I will send one each time you send a report card. The things on it seem to be important to me. Hope you agree.

MAKING A QUILT—If you have any old printed cotton clothes that you are ready to give up, please send them in. The children have learned that the pioneers made quilts out of worn-out clothing. If you don't have any and would like to buy a piece of a small print cotton material that would be great, too. I will need parents to help the kiddoes stitch the squares together.

PREPARING THE CABIN—The children will paint the cabin walls this week. Then we'll be ready to equip it and begin "living" the pioneer life.

TIME ARTICLE—I am sending home a list of things that Time magazine says are things parents can do to help children be top students.

rainbow connection," and the next year it might be *Panda Patter*, because the class's "mascot" is the panda bear. No matter what the title, though, the newsletter contains information about the current focus of instruction; how parents could help at home; upcoming events, dates, and reminders; invitations to parents to write or call about suggestions, and the weekly family "home fun," (rather than home "work"). (See Chapter 7 for more alternatives to traditional homework.) Figure 3.2 shows an excerpt from a three-page newsletter; not all newsletters are as long as three pages.

Karen's newsletters are a bit different. In hers, she simply types up information she wants to communicate to the families. Notice the variety of kinds of news she shares: a thank you, an apology and re-explanation of an academic project, a request, a reminder in one October issue of her newsletter (see Box 3.1).

Box 3.1

News and Notes 10-11-01

THANKS to everyone that contributed to our Fall Festival's success! We sure appreciate all that you do to help the school out and we couldn't do it without such kind, helpful, caring parents! The contributions to our "paper basket" were great. We had some really neat things in it! Thanks so much for the stuff! (By the way, did the kids tell you about the lesson we had with it? In groups, all the great things were sorted in ways that had similar characteristics. We learned that all 3 groups had different ways of sorting the same things!) Also thanks for sending in the 2 liters. Thanks to you that worked and thanks to you that came. Thanks for your support at the auction, too! It sure was a fun afternoon/evening and was great to think it would all help to benefit our children!

I AM SORRY FOR THE CONFUSION WITH THE READING RESPONSE JOURNALS LAST WEEK! I thought I had explained it really well, until the next day when I looked at the journals and realized I had confused everyone! I am sorry. I think we are all on the same track, now, but just in case, let me briefly explain again. Read every night Mon.-Thurs. Record titles, date, etc., on the Reading Log page (with orange heading). On the pages after that, respond to what you have read on THREE of those nights. When responding include the title that you are responding to and then respond by telling of, what it made you think of, what it reminded you of, if you relate it to your life or other books you've read, or retell it. If you give your opinion, tell WHY!!! Use the fronts and backs and be sure to read my comments. You may respond to me, too! When the "Log page" is full, I will paste in a new orange header and then you'll log your books on that page and respond after that! It is my wish that my students read, and I am happy to say that most are!!!

We have been reading *The Mouse and the Motorcycle*. If you can think of some object to bring in that relates to their story, please bring it in. We will be making a mobile about the book. If someone brings in the same item, we'll use the first one that was brought in. Think of the story and think of the many things that happened. Think of things at home that were mentioned in the story. For example, they mentioned some old tissues that the mice had in their mouse hole. I am bringing in an old tissue and that will be the first thing on our mobile. Now you think of other,

Box 3.1 Continued

different things. You must be able to tell its relationship to the story. It will be fun to see what you all think of!

I will send home the Reading Workshop papers from the previous week on Mondays (or Tuesdays if I can't get them graded by Monday). This will let you know what is getting accomplished during our reading time.

--

Return

Child's name

Parent's signature

TAKE A LOOK: PHOTOS AND VIDEOS ■

Another way to communicate with families that the families particularly enjoy is through pictures. You can send an album of photos representing the activities and work of the class home with each child for a day or two. Be sure all children in the class are represented. This provides a lot of information for parents—the faces of children they haven't met but have heard about, the kinds of activities in which the children participate, or the kinds of work produced in the classroom. Karen makes a video of activities that happen in her room over several weeks' time. In it she shows children working together, her own instruction, and student work samples. The children take the video home for a day or two, but get it back quickly to keep it circulating. It is important to be a bit flexible about when it comes back because not all families have VCRs, and they might plan to view it at someone else's house. If a family does not have a place to view the video, offer the school's VCR when it is convenient for the family.

SUGGESTION-RESPONSE BOX ■

The old-fashioned suggestion box can still be a valuable tool for teachers or the school in general. The problem with the way it has often been used, is that the communication has been one way—from home to school, with no response from the school. If a suggestion box is established, and parents are making requests or suggestions, they will want to know that their ideas are being heard and considered, even if the request is denied or the idea does not catch on with others. First, the box must be placed where parents can contribute anonymously. Then it must be established who reads the notes and where the ideas will be explored (at faculty meetings, site-based council meetings). After discussion, a designated person then writes a response and posts it on a designated bulletin board near the box so that families can anonymously read the responses as well.

■ COMPLIMENT BOX

Right next to the suggestion-response box can be a box identified as a place to thank members of the school staff, from lunchroom and custodial workers to principals and teachers. These notes could be transferred to the personal boxes of the employees. We want to communicate to families that giving constructive criticism means making suggestions and giving praise equally, just as we try to do in our classrooms.

■ HOMEWORK COMMENT SHEETS

Most of the time families spend involved with their child's education is in keeping track of whether homework has been completed. Occasionally, or even often, parents perceive the homework as inappropriate for their child. A simple way to communicate with families would be to have a place on or attached to the students' work that allows parents to comment. A parent may want to say, "This seems too easy for him," or, "She didn't understand, and I couldn't help," or even, "He can do the math problems but gets tired after 4 or 5. Twenty is too many!" It lets teachers know that effort was made to involve families and keeps the communication between home and school flowing.

■ DAY PLANNERS

Many suggestions about communicating take considerable time, and teachers can do this kind of work only periodically. But communicating daily can be important to some teachers. Karen's way of communicating daily with her students' families is through her Day Planner. This strategy is easy and effective because the students do the writing, not her. The Day Planner is a calendar with spaces to write assignments and reminder notes. Children initiate the communication by writing a note or assigned homework. Parents and teachers can write back and forth in the planner, and so do not have to be concerned with lost notes. If the notebook goes home daily, parents get used to the routine, and it becomes an invaluable communication tool.

In the October Day Planner (Figure 3.3), the child wrote assignments, a note, and was practicing what she learned. On Tuesday, her mother requested a call from Karen, and Karen responded that she would call. By Wednesday evening, the mother was saying thanks and apologized for something, to which Karen replied, "That is okay!" On Thursday, the parent wrote again, explaining that her daughter wasn't able to do her reading the previous evening, but that she would that evening.

In the January Day Planner (Figure 3.4), the child writes assignments and notes to himself. His parent asks what will be new this month, and Karen responds with a list of her planned academic instruction for the next few weeks. Later that week, the parent praises her child's handwriting and Karen agrees. These simple tools can go a long way toward informing parents and creating the kind of positive relationships between home and school that enable student success.

Figure 3.3
October Day Planner

1999

This Week's Goal

| Monday October 4 | Read. |
| | *Debbie Adams-Ross* |

| Tuesday October 5 | Be Reading 10 books for bookIt |
| | *Debbie Adams-Ross* — *Call me please. Thanks, Debbie* |

I will call! KM

Wednesday October 6	Fundraiser begins — *Thanks I'm very, very sorry. Debbie*
	That is okay!!! KM
	Debbie Adams-Ross

Thursday October 7	Have a happy day today
	Mrs. Miller; Cassie didn't read last night, but I promise — Debbie Adams-Ross
	she will tonight, Thanks, Debbie

Friday October 8	Buenos dias
	Buenos Tardes — *Debbie Adams-Ross*
	Buenos noches

Saturday, October 9

Remember

Figure 3.4
January Day Planner

JANUARY 2000

	Language Arts/Reading	Social Studies	Math	Science
	Have a good day.			
10 Mon	*og*		*What will be new for "2000" in class?*	
	This week we are revisiting multiplication & we are opening the "Ruby Flower Shop" & studying simple machines. Beyond that, I'm not sure yet! KM			
11 Tue	Return computer	for education booklet?		
	og	KM		
12 Wed	Read for BookIt.		*Wow! Those math papers look great and what nice handwriting (better than mom's) And teacher's!*	
	og	KM		
13 Thu	One more to go	And then we have	3 days off.	
	og	KM		
14 Fri	No school on	Monday		

Parent Signature

Teacher Comments

10 Sun		9 Sat	

Weekly Goals

Figure 3.5
Sample Agenda

SEPTEMBER
2000

	Language Arts/Reading	Social Studies	Math	Science
18 Mon	Read pgs 10-12	No Class	Test review Test Wednesday	Ecological success due Tues *Jonnie wrote his notes in class. Did better. He needs to finish the conclusions to*
19 Tue	Vocab Quiz Writing Task Work sheet	Golden age Greece NO H.W.	(redo mistakes) Finish/study Math test review PW	*Ecological success Due Tues.* PW
20 Wed	Writing task Worksheet – Fri Vocab Quiz.- Fri.	No Class	Math Test	No H.W.
21 Thu	No H.W.	Greek ideas to Olympics No H.W. PW	No class	Write up due PW tomorrow *Did well in class today*
22 Fri	quiz tues Mon 3 leads and Graphic organized PW vocab words	1. Fill out writing task 2. How are you going to develop your ideas? Look at supporting details handout.	PW	We did peer response today. He needs to turn in revision on Monday

Parent Signature *Jonnie informed me that the 2 assignments I've singled out*
Teacher Comments *are the same. Please verify for me.*
 Thanks, Patricia Watterson

		23 Sat	

Weekly
Goals

		24 Sun	

■ **THE AGENDA**

In both Vickie Wheatley's and Dena Kent's middle schools, students write in an "Agenda" much like Karen's Day Planner. In the sample Agendas in Figures 3.5 and 3.6, the students write assignments and reminders, and Vickie checks when the homework was completed. There is a space for a parent signature, and on the first one (Figure 3.5) the parent used it to ask Vickie a question. In the second (Figure 3.6), Vickie communicated to the family member (in this case, the grandmother), requesting help in getting the student's homework assignments completed.

The Agenda has been a valuable tool for middle school teachers, students, and families. Vickie has said that next school year teachers in her school intend to write on the Agenda page the state academic standards they are working toward during that week.

Figure 3.6
Sample Agenda

SEPTEMBER
2000

	Language Arts/Reading	Social Studies	Math	Science
4 Mon	Paragraphs *PB.*	NO class Still need to do 137-141	1,7 ordered pairs Hw. 18-26 Pg. 39 *PB*	Study for vocab test, Test thurs
5 Tue		It's up there ↑		
6 Wed	2 vocab words due friday	H.W. worksheet due friday Sept 14 ss test *PB.*	No Class *PB.*	Cell mobile Due. tues. Study for test on Thurs. *See teacher comments*
7 Thu	Due Mon. 2 pages	No Class		No H.W. Test
8 Fri	Party	Quiz	POW 4 column due Monday	Cell mobile Due wed.

Parent Signature	*Grandma*

Teacher Comments *Hello! I am trying to help Jeff get his notebook organized and missing
assignments caught up for Friday. I would like for him to work on the full ship activity. It wasn't
finished. He needs to study tonight for his vocabulary. Test tomorrow (Thursday).*
Thanks for you support!

9 Sat

**Weekly
Goals**

10 Sun

FAMILY MESSAGE JOURNALS ■

Family message journals (Wollman-Bonilla, 2000) are notebooks in which
children write a message to their families each day about something they
did or learned or thought about in school, and a family member writes a
response to that message. This technique, like Karen's Day Planner, is sim-
ple to include in the school day. Its powerful benefits come when the child
writes about academic concepts. We know from research and theory on
writing development that we learn concepts through the process of
writing about them; we make our knowledge explicit and come to new
understandings as we write. The family message journal can not only
communicate with families about what is going on in school, but also, like
the learning logs described in Chapter 7, help the child integrate his or her
understandings about what was taught.

At Dena Kent's middle school, many teachers are using "writing home" as a way of improving the writing of their students. They have students write notes, comments, and questions to a family member, and the family member responds. This dialogue gives the students an authentic audience and an opportunity to communicate with their parents about topics they may not feel comfortable talking about face to face.

■ FAMILY STORIES

Collecting family stories orally or in writing is another way to get to know families, build positive relationships, and eventually improve instruction for students. In our work for the CREDE project, we visited the homes of some of our students (see Chapter 5 for more on Family Visits). After several visits, we interviewed families about their work, leisure, and histories. We transcribed the interviews to have a written account of the families' stories. The perspectives we gained opened lines of communication we never expected. For instance, one mother told us,

> I want Missy to be a respectable person and respect others and to do what she has to do to make it, you know, at that point in time. But I don't want Missy to be like I used to be. I used to be real quiet, let everybody run over me. I want her to take up for herself because if I'm not there, you know, when God decides its time to check me out, she's going to be looking out for herself. I want her to be able to do that without people looking down on her or look-ing, you know, on AFDC. [The most important thing] is loving [your child] unconditionally. When they're bad, you know, when you're off squabbling, I still love Missy. Even when we don't agree and we don't get along, I tell her, I say, "You know, I still love you."

From this interview, Missy's teachers learned that the mother wanted her child to be respectful and independent. Just knowing the mother has these goals has heightened the teachers' awareness of what they can do to help her accomplish these goals. In another interview, a parent explained,

> He [her son, the student] sometimes dawdles in the mornings, and when I come back from the fields, he still ain't ready, and I got to get him goin' or he won't make it [to the bus on time]. [We ask about the fields]. Oh, I'm working tobacco, every bit of it, except for cutting. It's hard work. And you know, you got to do it right. It counts on if you start out doing it right, then the end when you're strippin' all that, it's gonna come out right. To know what you are doing, it's hard work. If you don't get the suckers, it's a mess. . . . If you don't get all the weeds out, you have to cut down weeds as you're cuttin' down tobacco. You gotta do things right from the beginning. He [her son] needs to learn work at a young age. It builds it [the ability to do things right from the start].

This mother clearly wants her son to learn to work hard and to build a strong character because she knows these values herself. The teachers of

these two students had not been fully aware of how hardworking some of the parents were, or how much the parents think about how they are raising their children. Knowing family backgrounds can help increase the respect we have for them.

Learning family stories is becoming popular for understanding students' backgrounds and for building curriculum related to their backgrounds. (See chapter 6 on ways to connect the curriculum). In *A Path to Follow: Learning to Listen to Parents* (Edwards, 1999), the teachers ask different, but similar questions. They invite families to tell about the following categories: (a) parent/child family routines and activities, (b) child's literacy history, (c) teachable moments, (d) home life, (e) educational experiences, (f) parents' beliefs about their child, (g) parent/child/siblings relationships, (h) parents' hobbies, activities, and interests, (i) parent/teacher relationship, and (j) parents' school history (p. 36). These accounts are then transcribed in written form, and like those from the CREDE study, are shared with the families.

STUDENT-LED CONFERENCES ∎

In both Vickie's and Dena's middle schools each year, students lead conferences with their parents or guardians about their academic progress. Vickie explained,

> We wanted to shake things up a bit, and introduce the idea that students, to some extent, are in charge of their own learning. We wanted to change our students' perceptions of themselves as "empty containers" to "control-tower operators," complete with all the intensity and responsibility that job entails. A little nervous excitement in education is a good thing.

To help students prepare for the conference, Vickie and her colleagues gave students organizational guidelines. Students were asked to think about the following:

- What has been taught this quarter?
- What work did you enjoy most?
- What skills do you need to work on?
- What is your best piece of work from this class?
- What goals can you set for yourself?

Students reflected on the school curriculum and their own learning, and they began to see that not all learning is created equal; some learning is more engaging, some tedious, some more challenging to them personally. Then, in each subject area, students were guided to create questions specific to that subject. The questions for social studies were:

- What do I feel more confident about now than at the beginning of the year?
- What social studies concepts do I feel I could teach someone else?
- What do I need help with in social studies? Who can help me?
- A good strategy for me is . . .

Box 3.2

Dear 6-C Parents,

Thank you for coming to our student-led conference. We know that many of you have made difficult schedule adjustments and have been otherwise inconvenienced in order to attend. Your child has worked hard to prepare for this conference, and we believe you will enjoy it and learn a lot from his/her presentation.

It is not the purpose of student-led conferences to replace parent-teacher conferences. Their purpose is, instead, to give parents and children an opportunity to meet together, in the school setting, to discuss the child's progress, strengths, and goals. It is hoped that the organization and more formal setting of these conferences will make them more informative and detailed than daily conversations at home would be.

Another advantage of this student-led format is that the children should begin to take a greater responsibility for their own learning experiences. We have, indeed, noticed a change in many of the children's perceptions of themselves and their school environment as they have progressed through conference preparations.

As you participate in this conference, please feel free to ask your child questions and to make comments. We will be available to join you if you have any specific questions about subject areas. However, we hope you will let your child move through the materials at his/her own pace. You may be pleasantly surprised about his/her insight and sincerity.

We are, of course, still available for parent-teacher conferences any school day from 11:00 to 11:45. Please call the office to let us know you would like an appointment.

Thank you again for your support of this program. We hope you find your conference valuable and enjoyable.

Sincerely,
Teachers From Team 6-C

Then students collected their own work samples and scoring rubrics to illustrate what they would report to their parents. The conference evening was scheduled with family members signing up for a twenty-minute slot. As students talked with parents, teachers rotated around the room, stopping briefly to chat or answer questions. "Regular" parent-teacher conferences were held earlier in the year, so at this time introductions were usually unnecessary.

When families arrived, students were given a conference checklist that included guidelines:

- Have parents say hello to teachers
- Pick up your portfolio
- Review your Agenda daily assignment notebook
- Discuss each subject area self-reflection
- Show samples of your work to support your reflections
- Review your goals with your parents
- Complete the post-conference reflections sheet with your parent

Box 3.2 shows an introductory letter inviting parents to participate in this process. Sample comment forms are in Box 3.3 and Box 3.4.

Attendance at these conference sessions was high, much higher than at traditional conferences. Involving children in planning and doing the actual conferences not only supported reflective learning, it got more parents in the building.

Box 3.3

Post-Conference Parent Reflections

Dear Parents,

Thanks for attending the student-led conference. We hope that this conference was a positive experience for you. We would like to know how you felt about this conference. Could you take a moment to answer the following questions?

Thanks again for your time.

1. Was your child adequately prepared for the conference?
 Yes No

2. Do you have a better understanding of your child's learning so far this school year?
 Yes No

3. Do you feel that the format of the conference provided you with adequate information?
 Yes No

4. Are you satisfied with how your child is performing in school?
 Yes No

5. Do you feel the Student-led conference was productive?
 Yes No

6. If not, please suggest ways to improve upon this format.
 Yes No

7. Please provide us with any additional information which you think will make conferencing more productive for your child and you.

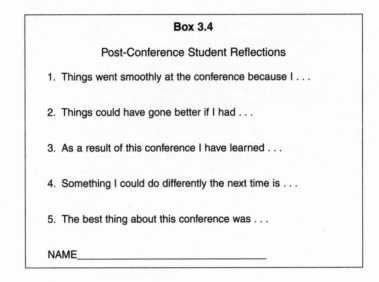

Box 3.4

Post-Conference Student Reflections

1. Things went smoothly at the conference because I . . .

2. Things could have gone better if I had . . .

3. As a result of this conference I have learned . . .

4. Something I could do differently the next time is . . .

5. The best thing about this conference was . . .

NAME_____

■ VOICE MAIL

Principals can help home-school communication by providing voicemail for all teachers in the building.

Voice mail lets parents leave messages as soon as they have a question, issue to discuss, or important information about their child and be assured that the teacher will respond soon. This helps teachers know what parents might be worried or concerned about, avoid potential problems before they escalate, or find out something they need to know about a particular student.

■ PHONE HOME

Parents often assume that a phone call from the school means there's a problem. Diane remembers an experience from her family. Her sister Joanne's son, always a very good student, entered middle school. During the first week, Joanne received a call from one of his teachers, and Joanne panicked, thinking, "Oh no, one week in middle school—what could be wrong?" But luckily, this teacher was making positive calls as a way of reaching out to parents. She told Joanne, "We just wanted you to know that we are so pleased Jason is part of our team. He's had a good first week, and it looks like he's going to be a good kid to work with. We are looking forward to meeting with you and anyone else in the family." Joanne got off the phone and

Principal John Finch calls many parents in the school during the school year, and he says the effort is well worth it.

almost cried. She thought about how he had been a good student for six years, and this was the first time any teacher had ever made a positive call.

We recommend that teachers call every student at least once during the school year, to talk with both the student and the parents, if they are available. A call at a particular time in a student's life—whether it is about an important ball game or a grandparent's surgery—can be profoundly effective in building positive relationships. But calling to compliment, like the call to Diane's sister, or just to say hello can be effective, too. All children, even middle and high schoolers, feel a sense of pride and warmth when they get a positive call from their teacher.

Gayle and Karen have each made it a practice of giving their home phone numbers to parents, urging them to call if they have a question or concern or some important information they feel the teacher needs to know. They both feel it's better to get a call than to know that one of their families has spent an evening being upset or concerned about something at school. In their experience, parents have appreciated the teacher's accessibility and have not abused the offer.

Gayle: If I were starting now, I would call parents more often and give them good reports and tell them funny things their child did, ask them questions about what they did at home. It's time consuming I know, but I think it's very valuable.

Karen: I'd let them hear more positives than in the traditional school setting where all they hear are the negatives and see are poor report cards at conferences. I think the best advice is to take it a step at a time. I know a lot of people may not want to make the family visits. But, there are other ways of connecting with families: making phone calls, sending cards . . .

"HOW-AM-I-DOING?" SURVEYS ■

Perhaps the riskiest activity for teachers is to ask parents or guardians to critique their child's instruction. Of course, asking for parents' opinions is one of the best ways to build trust with families and improve instruction to better meet the needs of students. We advocate this activity because we as teachers cannot know everything that is going on at school with particular students and among the students. How could we? Keeping track of children's social, emotional, and academic needs is an overwhelming task that teachers cannot do alone. Yet, parents often hate to burden teachers with special requests for their children. But teachers *will* often make changes and attend to needs of particular children if they are better informed. For example, twice a year Karen surveys her parents to assess her own teaching and to make future plans. She sends home an eleven-question survey asking families their opinions about her teaching, homework, best and worst things about the school year so far, and their concerns. Last school year, every parent responded. Several provided insights that Karen had not had, which helped her to be more in tune with the needs of individuals. In the samples in Boxes 3.5 and 3.6, the mothers express their opinions and concerns about what is going on with their children so far. Karen has used this information to ensure that Jane selects appropriate books to read at home and that the second child gets his News and Notes memos home. She has also worked on helping him with his responses to the readings. This kind of information can help teachers understand children more and be more sensitive to their needs.

Box 3.5

I am interested in finding out your opinions about your child's school year. If you would, please complete this questionnaire so that I may use your input as I rethink and assess my teaching practices. You may leave your name off or sign it. I thank you for your help.

Is your child having a good year? Please explain why or why not.
Yes, because she likes being in your class. You make her feel at home.

Does your child like school? Explain.
Yes, she has always loved to learn and be around other people. She also likes her quiet time.

Do you see your child growing academically? Explain.
I'm not sure how much she has grown.

Do you see your child growing socially? Explain.
Yes, she enjoys working in groups and seems to get along with others and at the same time she usually stands up for herself.

Do you think your child is treated fairly?
Yes, in the classroom. My concerns come from lunch—I don't understand why the entire class has been punished at times because of some being too loud. (But I'm only hearing one side of the story.)

How do you feel about the communication between school and home?
I like the News and Notes on Monday. I think it is a wonderful tool.

How do you feel about the reading homework?
I don't feel that Jane chooses books that will challenge her enough. However, I am glad that she reads on a regular basis at home,—and loves it.

How do you feel about the assigned projects?
I like them not only for the family involvement that takes place, but also for the presentation.

Gayle used a different survey (Box 3.7) to elicit similar information from the students' families. She too, received much feedback that helped her understand how the families perceived what was happening in the classroom.

Box 3.6

I am interested in finding out your opinions about your child's school year. If you would, please complete this questionnaire so that I may use your input as I rethink and assess my teaching practices. You may leave your name off or sign it. I thank you for your help.

Is your child having a good year? Please explain why or why not. *My child is having a good year. He seems to be more alert and more involved in what's going on.*

Does your child like school? Explain. *Yes, my child likes school, he likes his teacher and activities she plans.*

Do you see your child growing academically? Explain. *Yes, my child seems to be doing better especially in reading.*

Do you see your child growing socially? Explain. *Yes, because I see him wanting to be involved with other kids.*

Do you think your child is treated fairly? *Yes*

How do you feel about the communication between school and home? *I feel that the communication between school and home is O.K. Although sometimes I don't receive the news and notes.*

How do you feel about the reading homework? *I feel like it has done my child good to do the reading homework.*

How do you feel about the assigned projects? *I feel like the assigned projects give them something to do instead of other things like t.v. and videogames. It gives them something to really think about.*

This activity sends the message to parents that as teachers we value what parents think, that we care about each student's individual needs, and that we will change things to better meet the needs of the children. Yet, it can be risky. If the majority of parents have concerns you knew nothing about, it can be difficult to take. If several parents do not understand or like some aspect of your teaching, will you be prepared to change? What if your goals differ from theirs? How will you begin the conversation that would need to come next? These are issues for which we need to be prepared when we take the risk of asking parents their opinions. Gayle, for example, decided to implement a whole new approach to homework in her class a few years ago. She explained at the Open House early in the year and in a letter to parents that she believed much of what parents and their children did together outside of school already involved valuable learning opportunities for the children. Gayle wanted to "rethink" the idea

Box 3.7

Student Name **Joseph Davis**

Is there any new information you would like to communicate to us?
Joseph has recently shown a much stronger interest in reading and meeting/exceeding A/R goals.
Do you have any comments or concerns about your child's progress or school activities?
No.
Would you like us to call you at home or schedule a conference to discuss your child's progress?
We would like to schedule a conference to discuss Joseph's reading level.

Nancy Davis

Student Name **Tom Parson**

Is there any new information you would like to communicate to us?
We have given Tom an incentive to read more challenging books. We have already seen an improvement. Let's hope he keeps it up.
Do you have any comments or concerns about your child's progress or school activities?
We have talked to Tom about putting forth more effort in everything he does; such as his reading. Hopefully it will bleed over into his writing abilities.
Would you like us to call you at home or schedule a conference to discuss your child's progress?
Yes, please.

Janice Parson

of homework and, instead of "assigning" homework each week, wanted the parents and children to share in some way (written notes, photos, oral presentations, artifacts, etc.) what they had done together and what had been learned. Gayle felt this would help her find out a great deal about the children and their families that she could build on in her teaching. And, she assumed the parents would love being freed from the "homework battles" they often described. Not so! It didn't take long before Gayle, having asked how it was going, started hearing complaints about parents' not understanding what was expected and concerns that the children should be spending more time at home practicing the "3 Rs." Gayle reflected,

> Maybe I could have explained it better, or maybe shared more examples. I really thought everyone would love this idea, since

homework often seemed to be such a source of stress in family life. But, it all seemed too different to them, and, to be honest, I think some parents wanted homework for their kids to work on so they could have time to fix dinner, pay bills, or do other chores and not be interrupted. Having raised two children while working full-time, I could relate to that in some way. After a few more attempts at explaining, I started preparing more homework assignments. I still encouraged them to continue with what I'd suggested at first, but I ended up giving them other options as well.

Yet, we believe the trust you build with families through this kind of activity is worth the risk, because parents become your allies when they believe you care. This kind of survey can also help teachers discern where communication breakdowns may occur, and can help teachers decide better how they can work more collaboratively with parents on common goals.

SUMMARY ■

In this chapter, we have shown ways of establishing positive communication with students and their families. Teachers and principals who developed and implemented the strategies have reported many worthwhile results for primary, elementary, and middle school students alike. Through such efforts, we believe we can help families feel more connected and students feel more welcomed and supported as learners.

4

Building Effective Partnerships Through Family Workshops

Some of the teachers with whom we've worked claim Family Workshops as their most successful activity for connecting with families. These events bring everyone together in an informal way yet with an academically purposeful intent. Students, their families, and teachers have an opportunity to get to know one another better, and teachers can find new ways of making connections in their follow-up instruction. In this chapter, we share reasons for planning such events, ideas for various types of workshops, and tips on getting started.

Traditionally, parents and guardians come to school after an invitation to an Open House, and they spend the evening listening to the teacher explain her curriculum, classroom rules, and homework procedures, followed by, "Any questions?" This kind of evening may still be quite useful. However, to increase involvement, connect with families in ways that build positive relationships, and ultimately improve student achievement, we must go beyond the "stand and deliver" method of involving families. Instead, we must plan, implement, and follow up with curricular ideas that connect home and school. Family Workshops provide one beneficial way of accomplishing such a goal.

Workshops usually mean a group of parents, teachers, and school support staff working together for the betterment of children and families (Vopat, 1994, p. 14). As Epstein and others have shown, workshops provide

a useful format for coordinating efforts around building effective partnerships (Epstein, Coates, Salinas, Sanders, & Simon, 1997). Workshops can take many forms and can accommodate large or small groups, depending on the building and personnel resources. In our experience, we have had much success with one-evening workshops with follow-up school and family curricular "work," as well as ongoing workshops that occur periodically throughout the school year. Other workshop structures occur each week for multiple weeks (Vopat, 1994). In our view, all workshops should have as much parent and child engaged time as possible.

Why have workshops? As we have said, these evenings typically draw more parents than traditional information sessions. But who is likely to attend Family Workshops? We have shared that there is a well-known difference that exists between middle-class and poor- or working-class families in attendance at school functions and parent-teacher conferences (Lareau, 2000). Middle-class families often attend functions, correspond with teachers, and make demands of schools for their children's best interests. Poor- and working-class parents often leave schooling to the professionals. Some of these parents believe that they should not demand or even ask teachers to make instructional adaptations for their children, because they believe that teachers know best. They also attend school functions much less often, likely due to their own feelings of insecurity in schools and their memories of their own poor experiences in these institutions (Epstein, 1986; Lareau, 2000). However, if we invite parents to participate in the planning and implementation, or have alternative ways of inviting families to these events, and we ensure positive experiences when they do arrive, we might bring in all our parents.

■ BEING WELCOMING AND AWARE

Since many parents themselves have had negative experiences in schools, they may feel uncertain about attending school events or unwelcome when they do. These are the feelings we want to eradicate. We hope to ensure that parents feel invited and secure when in the school. We want them to feel like this is *their* school, not the teachers' and principal's. We are here to serve them. So, when we plan Family Workshops, we must communicate how much we want and need them at the event, and how much we value their input in planning and making it a success for everyone.

Invitations can take many forms, and we suggest using a variety. Face-to-face invitations are the best, since you can immediately address any hesitations or concerns and show sincere interest in having all families attend. Another good strategy is a written invitation from the child (which offers an authentic writing opportunity as well). Including information in class or school newsletters or forms like Karen's Day Planner or Vickie's Agenda, described in Chapter 3, can be useful. For parents who have difficulty with reading or who do not speak or read English, however, we must find other approaches. Making phone calls and seeking the assistance of a translator may be necessary.

The workshop itself must accommodate all families, even those who speak little English. In one workshop at Principal Carol Miller's school, Ellen and Diane interviewed small groups of parents on their goals for

their children and desires in future workshops. As it turned out, all the Spanish-speaking parents ended up in one group. With her beginner's halting Spanish, Ellen was able to at least welcome the families and communicate the goals of what they were to talk about. She asked permission to tape-record the group's discussion, and this was later transcribed to get these families' perspectives. In any case, a commitment to reaching out to all families may require innovative ways of inviting participation.

CLARIFYING EXPECTATIONS ■

Through our successes and failures at these events, we have learned that being very clear about the expectations of the evening is important. For example, when Karen planned her Literacy Workshop, one of her students, Justin, questioned, "Will my dad have to read?" Karen had not planned for parents to read aloud, but she realized from Justin that the focus on books in the workshop memo might have caused some of her parents to assume that they would be expected to read. Karen assured Justin that his dad wouldn't be the one who would be reading, that Justin would do the reading and show his dad what a great reader he was. Justin was convinced that it would be a safe environment for his father. The two of them came, shared some great literature together, and had a wonderful time.

Gayle had a similar response when she began planning her Math Family Night Workshop. During many family visits, the parents (mostly the mothers) shared their concerns about how to help their child with mathematics. When Gayle planned to have a Math Family Night Workshop, though, several expressed hesitation (often in the form of joking around about how bad they are in math), even though they planned to attend. They simply didn't want to be embarrassed.

And for middle school students, knowing they will be expected to work with a parent alongside their peers and their peers' parents may bring about some fake fevers or worse to avoid the workshop. We must be sensitive to adolescents' feelings of embarrassment at what we might be asking them to do. It may be necessary to have middle school workshops in which the students and parents are separated during the workshop, but actually experience similar evenings. This may encourage communication about the evening once the families get home while avoiding the embarrassment so many students feel about their parents at this age. Inviting the students to help plan the event can help teachers understand what may or may not be successful with any given group.

From our workshops, we have learned the importance of clearly communicating what Family Workshops would involve and providing students and parents with the option of participating in some activities but not others, if they feel uncomfortable. Anticipating possible concerns ahead of time and involving families in the planning can help assure that all feel comfortable about attending and taking part.

In the sections that follow, we not only describe the workshops we have implemented, but offer suggestions for how to invite student and parental leadership and how to extend the learning from the workshop back into the natural activities of the home and school.

■ THEMED WORKSHOPS

While an evening with families does not have to have a theme, we found that a theme helped us organize activities around instruction that meets national standards (see Chapter 6), and at the same time kept us from getting overwhelmed or trying to cover too much. We also always provided food that could be dinner, because many families do not have time to feed their children *and* go to the school in one evening. We have served pizza, soup, sweets, and popcorn or, when we didn't have funds or by parental suggestion, we have hosted potlucks. In the following sections, we provide details about different kinds of workshops, all of which can be adapted to different grade levels, settings, and circumstances.

Literacy Family Night Workshop

Karen had a hunch that many of her students had never been to the town's public library. She wanted to create a workshop that would motivate families to use the library regularly and to share reading strategies she thought would be helpful. She decided the theme would be, "Plant a Seed and Read!" and she was able to secure funds for the event through her school's Extended School Service (ESS) program, which funds tutoring and other activities for children who need extra help. Several weeks before the scheduled event, Karen sent home invitations explaining the event and library card application forms, and informing families that part of the evening would be spent at the library. Using suggestions developed by McIntyre (1997), Karen created a brochure that explained the importance of shared book reading in families and some possible questions parents can ask their children during shared book reading. The brochure emphasized that these were only tips, not required homework for parents.

The trifold brochure contained pictures and tips in three main categories: (a) Selecting a Book for Your Child, (b) Increasing Reading in Your Home, and (c) Reading Together. In selecting a book, McIntyre (1997) suggests:

- Choose a book your child will enjoy!
- Decide whether you will read it *to* your child, *with* your child, or if he or she will read it *alone.*
- If the book is for independent reading, have your child open to the middle of the book and begin to read. If your child struggles too much, the book is probably too difficult (but could be used when reading together). If your child breezes through the book, help him or her select one a bit harder.
- It is most important that your child choose a book he or she *wants* to read.

For suggesting ways to increase reading (McIntyre, 1997), the brochure included:

- Read a book or two every day at the same time and place. (If you miss a day, just begin again!)
- Limit TV. (Watch the good stuff!)
- Have books and magazines around. Make reading easy by having materials close by.

- Read in the car, in the grocery, anywhere!
- Relax the bedtime rules once a week to stay up late to read.
- Cook and read a recipe together.

And, for shared reading, the brochure included:

- Find a book you know your child will enjoy.
- Show the cover of the book. Read the title, illustrator's name, and dedication.
- Take your child on a "picture walk." Talk with your child about the book while the child holds the book.
- Continue to let your child hold the book. Read the first page or two aloud slowly and ask, "What do you think so far?" Allow conversation about the book.
- Continue to read, using expression. Comment on what you think about the book. Talk in ways you would like your child to talk. Pose questions. Be thoughtful.
- Allow your child to set the pace. If she seems anxious for you to read, then read. If she wants to talk about the book, then talk. If she wants to do the reading, let her try.
- Encourage your child to follow the words with her eyes as you read.
- Keep it enjoyable!

The night of the workshop, Karen ordered pizza and provided drinks and cookies. She had also decorated flowerpots with reading slogans and used them as table decorations. Parents arrived and signed in and filled their plates while Karen mingled. After dinner, Karen shared the brochure and modeled examples of potential questions parents might ask. The families then drove to the town library. At the library, the children's librarian led the group on a tour, which Karen felt was too long. But by the time the tour was completed, many were showing enthusiasm about all the library had to offer, of which many had been previously unaware. They then had time to explore the library on their own, check out books, and hear some stories read by Karen's teenage daughter.

All of the children checked out books, and many began to read them right there in the library. Several families worked on the computers, and some commented that they had no idea the library had computers. Others found reference sources they hadn't known existed and were happy about that. All said they loved the occasion and thanked Karen for providing it. This was a first visit to the library for many of the families.

The following day, the students were quite enthusiastic to have been a part of the Family Night. It proved to be a rewarding experience for everyone. In the weeks that followed, one parent told Karen that she and her daughter had been back to the library many times to use the computer. Others commented that they were planning to go back. Throughout the year, Karen knew that some of her students were revisiting the library, as they brought books they had checked out to share at school. The seed was planted that books can be wonderful and that you can really grow through reading.

FAB:ulous! (Families and Books: Using Literacy Opportunities to Unleash Success!) was a schoolwide, two-year workshop program that met monthly at Principal Carol Miller's school. In this project, teachers, parents,

and other community leaders planned a series of workshops based on the academic interests of the children and families (surveyed on the first evening). One request was for ideas on how to help with reading. Funded by a state grant, the program provided food, entertainment or speakers, and a book for every child to take home each evening. After food and entertainment, groups of thirty parents met with five different leaders (teachers and university professors, including Diane and Ellen) who introduced great examples of children's literature and some tips for assisting when parents listen to children read. Parents practiced these tips with partners, and then regrouped later in the evening and practiced them with their children. These tips were printed on bookmarks that were laminated and distributed. One side read, "Teach Your Child This Strategy." It included,

- When you come to a word you don't know, skip it and read to the end of the sentence.
- Then, think about what word would make sense in that spot (where you don't know the word).
- Read that sentence again and look at the beginning letters and get your mouth ready to say the corresponding sounds. If you still haven't figured out the word, try sounding out each letter or group of letters. Then make a guess and read on!

The other side of the bookmark read, "Questions to Ask Your Child When He or She Misses a Word." It included these tips.

- Does that make sense?
- What word might an author use there?
- Read that sentence again.
- Does the picture help?
- Can you sound it out?
- Does the word have any small words in it that you know?

Parents appreciated these bookmarks as they provided a reminder of those hard-to-remember, on-the-spot prompts to use when children make errors. The free books were selected early during this evening so that parents and children could practice the strategies together.

The FAB:ulous! Project consisted of twelve events, focusing on mathematics, people of color (this school has a large population of African American and ESL students and families), sports, famous women, and reading and writing. During most of these evenings, the parents and children worked together on something. Once they wrote poems and hung them on the school walls where all families could see them as they entered the school building. Once they wrote little books about their families. Once they created a Bingo game around reading and writing tasks. At the end of each FAB:ulous! Program, children and parents together selected books for each child. The joint productive work and free books were overwhelmingly what parents liked most about these workshops.

Portfolio Workshop

In all Kentucky schools, students are required to complete a polished writing portfolio from the work they produced in their writing workshop

classrooms (Atwell, 1998). Students, and especially parents, are often overwhelmed with terminology such as *focus, audience, purpose, reflection,* and *writing process.* They are often equally confused by the statewide scoring rubric that determines whether students receive a rating of novice, apprentice, proficient, or distinguished. To educate students and families in a fun way, middle school teacher Vickie Wheatley and her colleagues plan to host a portfolio workshop for interested families.

The four topics they intend to cover include: (a) overview of what the writing portfolio is, how it relates to the writing process, and how content is learned through writing; (b) types of writing included in the portfolio (personal narrative, fiction or poetry, analytic reflective) and samples of each; (c) the scoring criteria and samples of papers at each benchmark; and (d) how parents can help students revise and edit their work.

The students and parents will participate in learning center activities (together or in separate rooms) for each of the above topics. The teachers have planned several activities to get participants revising texts that came from Barry Lane's (1998) *The Reviser's Toolbox.* They plan to have participants identify types of writing and score some samples. The evening will end with opportunities for parents to borrow videos on the state writing guidelines developed by the state's educational television.

Mathematics Family Night Workshop

As mentioned previously, Gayle discovered during family visit conversations how insecure many of the parents felt about helping their children with mathematics. They shared many stories of their own struggles in learning math and in understanding math as an adult and made comments such as, "That's something his dad has to help with," or, "I think the math homework is *hard*," or, "We're not sure how to help."

Having already had a well-attended Literacy Family Night Workshop, Gayle decided to plan a follow-up Math Family Night Workshop. She hoped it could provide some help and assurances for the parents and a basis for later instruction in the classroom (see Kyle, McIntyre, & Moore, 2001, for more details on this evening's program). From interviews, Gayle learned that many parents worked in either food preparation jobs or had an interest in and were good at cooking. Gayle responded enthusiastically when one parent suggested a potluck for the evening. She knew this could provide an important connection for the evening and subsequent teaching (see Chapter 6).

Gayle asked each family to "do math" at home by using the measurements in a recipe to prepare a favorite dish for the potluck and to bring the recipe for a book everyone would later receive. The night of the workshop, the children and their parents put the foods into appropriate categories, such as appetizers, salads, meats, vegetables, and desserts. The meal took place with much conversation about what had been brought, who brought what, and the recipes for particular dishes.

Following dinner, a well-known mathematics educator from a local university (who had been Gayle's teacher—something the children loved learning about) involved the families in many activities designed to help increase mathematical understandings. The families worked together with manipulatives, listened to the story of the tangram, worked with tangram puzzle pieces (Photo 4.1), and solved problems using M&Ms.

Throughout the evening, the comments the presenter made as he walked around modeled the kind of "parent talk" that would be supportive of children's efforts:

- "Stick to it."
- "Come back later and try again."

He also shared tips for "Doing Mathematics With Your Children."

- Make it fun by being positive.
- Focus on the process rather than the answer.
- Give nudges, not answers.

And, each family also received a packet of materials and a bag of M&Ms so they could continue the activities at home.

Parents' comments at the end of the evening and in the days that followed showed how much they enjoyed the evening and learned from it. The following provide just a sampling of reactions:

- "I learned new ways to help at home with math."
- "I liked seeing how much our children are able to have fun with math."
- "I learned about working with the tangrams" (see Box 4.1).

However, they also contributed to the evening by sharing from their "funds of knowledge" (Moll & González, 1993) about food preparation and recipes. From this contribution, subsequent problem-solving instructional

Box 4.1

Name (optional)(Older sister who brought younger brother to event)

1. What did you like or enjoy doing tonight?
 Tangrams (putting them together)

2. What changes or improvements would you suggest for our next Family Night?
 groupwork (involvement with other students)

3. What ideas from tonight do you think you might try at home?
 study/homework habits

4. Any other comments?
 I feel this is a great way for children to connect with their parents, but it should also involve interaction with other children & getting to know their families as well.

activities that had personal meaning for the children evolved in Gayle's classroom.

Making Art Family Night Workshop

Two teachers we worked closely with, Ruth Ann and Stacy, also hosted Family Workshops. They interviewed parents and invited them to share what they knew with the rest of the group. We were all surprised when a quiet, reserved man, a father of one of the first graders, said he would like to plan and direct an "Art Workshop." We provided the snacks and the supplies and said we would assist in any way.

The evening of the workshop, the father explained to the group of well over 100 family members, "We're going to have some fun and learn about color and space." He spoke a minute about how sometimes when we draw, we use only part of the paper, and that even when you draw something small (he used the example of an Easter egg), it should fill up the whole page. He said, "When you color, you should color in all the white space." He explained that each family would get a large piece of chart paper for each one of their children, and the parents or older siblings were to trace the body of the child on the page. Then children and adults together would color in the figure as they chose with crayons, markers, or paint. They all chose either markers or paint. Some families colored the children's figures wearing the clothing they had on that evening. Others put them in costume such as Army fatigues or a cheerleading outfit. Families worked together on their masterpieces. All the drawings were hung up in the cafeteria and kept there for a week. The big, bold, colorful artworks brightened the room and stirred conversation.

Families as Experts Family Night

After successful Literacy and Math Family Night Workshops, many of Gayle's parents asked, "What are you going to have next?" Like Ruth Ann and Stacy, Gayle responded, "How about you teaching this time? The children would love it! Would you be willing to share with the other families about . . .?" Gayle talked with parents she saw at school and sent a note home to all of the families (Box 4.2).

Box 4.2

FAMILY SHARE FAMILY NIGHT
Thursday, May 27 6:00-8:30

Dear Families,

Please mark your calendars for **Thursday, May 27, 6:00-8:30, including dinner** for our final Family Night for this year. We've had such a wonderful response to our reading/writing and math Family Nights, and we're hoping all of you will be able to come to our Family Share Family Night. We'll provide childcare for the younger children.

I'll be calling you soon to find out if you would be willing to share about a hobby, collection, your work, etc. (You decide!) I think it's so important for children to see their families as having knowledge to share and also to value the knowledge that other families can share. These school-home connections mean so much.

After dinner, we'll have a "show and tell" time in the cafetorium. Everyone who is sharing will have a table, and we'll arrange the tables around the room. All of us will then move from one "sharing" to the next, with each having 5 minutes to share. That's not a lot of time, but we want to include everyone.

For dinner, we thought it would be fun to have a cookout. We'll provide the paper products, drinks, and ice cream for dessert. Someone will be calling soon to coordinate the rest of the food, grills, etc.

Here's the agenda we're thinking of:

Cook-out and outdoor play for the children
Family Share time
Final comments and evaluation
(We'll figure out times as soon as we know how many will be sharing.)

I look forward to talking with you soon about this and hope you will be part of Family Night.

Sincerely,

Gayle Moore

Having spent much time in the families' homes, she knew about their hobbies, skills, interests, and occupations, so she could suggest such things as, "your collections," or "your Mary Kay business," or "your lawn care equipment." While some were initially hesitant about talking in front of a big group, many agreed. In fact, eleven of the twenty-four families agreed to share, although one ended up having to coach her softball team the night of the event (the interest she was going to share!), and another was ill.

The evening began with a cookout. Two families brought grills for hot dogs and hamburgers, and everyone brought some kind of picnic food to share—lots of chips, baked beans, taco salad, fruit, fruit salad, watermelon, cookies, candy, drinks, and ice cream. For about an hour, everyone ate at the school's picnic tables, talked, and generally enjoyed being together.

The group then moved to the parking lot in back of the school. Four families had requested to share outside, with each taking about fifteen minutes until all had shared. Everyone then moved into the cafeteria where the rest of the families had set up to share and followed the same procedure, moving from place to place. As the evening ended, Gayle invited each child to select a book to take home to keep (funded by our research project).

What funds of knowledge did the families share that night? A wide range, to be sure (Photos 4.2 and 4.3). For example, one father made arrangements for an EMS unit to be there, so he could share his work as a paramedic. Another father brought his truck and tree climbing and trimming equipment, and another brought a portfolio of his artwork. One mother brought her Mary Kay products and another brought nursing equipment, including a stethoscope to try out. Another brought her collection of Griswold ironwork and Jewel T china. Her daughter brought her collection of masks, and her son (the student in Gayle's class) brought his collections of Beanie Babies and cars. Another parent and child shared their pet box turtle and how to care for it, and another parent and child demonstrated learning how to play golf.

Photo 4.2
Family sharing about tree care business during Families as Experts Family Night

Photo 4.3
Family sharing about
collections during
Families as Experts
Family Night

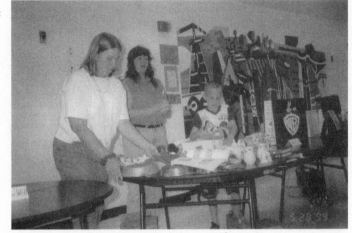

Many of the parents involved the children, asking their own to help make the presentations and asking other children to be participants in activities related to what was being shared. During this time, Gayle found it both affirming and informative as she listened to the knowledge the children shared during the presentations, knowledge from their own backgrounds and from the connected classroom instruction they had experienced. For instance, when one father talked about trees, the children showed how much they had learned while studying endangered environments and plants. They knew what products come from trees, and they asked meaningful questions of the presenter. But they also knew about trees from their own rural experiences, and were able to share that as well.

This event celebrated families' funds of knowledge. It also provided an opportunity for families to appreciate each other's knowledge, expertise, and interests, as they got to know each other better and discover common connections. Several families made connections that night—about whom to call for problems with trees or lawns, and who might be a good resource as an artist for the local historical society. Everyone seemed genuinely interested in what others shared, and they enjoyed finding out more about one another. At the end of the evening, one mother said as she left, "Thank you for being the kind of teacher who cares enough to have an evening like this."

■ MORE IDEAS FOR FAMILY WORKSHOPS

Successful family workshops generate ideas for more family workshops. We have found that families who attend one workshop and find it beneficial (and fun) will soon ask, "When is the next workshop?" or "Why don't you have a workshop on . . .?" This provides an opportunity to begin to involve parents in the planning phase—topics, agendas, logistics, and so on. And, in that process, they will offer topics they find meaningful.

Besides the types of workshops we have described above, many other possibilities exist in a typical school's curriculum and community. Below, we offer some ideas to begin some brainstorming in your setting.

Interdisciplinary Units

Many teachers organize their curriculum around interdisciplinary themes. Since these units tend to last over a span of several weeks, incorporate knowledge from several sources, and involve different types of activities, they afford an excellent opportunity to include a family workshop as well. This could be a time when families could share their knowledge related in some way to the theme as well as learn new knowledge from others. For example, a theme focused on "change over time" could lead to families' sharing about such things as crop rotation or gardening, grandparents' reflections, or creating a craft from beginning to end. A theme focused on "economics" could enable families to share what they know about family businesses, yard sales, bartering, and so on. Another theme could focus on "histories," during which families could share what they know about family, local, or national history of their cultural group. They could bring in artifacts to share, tell stories, discuss controversies, and so on. It just takes a little imagination to come up with new connections and to expand the curriculum in ways that build on family knowledge.

Other Curricular Areas

We have described family workshops focused on literacy, mathematics, and the arts. However, other areas of the curriculum could just as easily provide the starting point. Science and social studies, for instance, offer a wide range of possibilities that could engage families. Families represent many kinds of occupations, hobbies, interests, and other experiences and may know a great deal about such curriculum-related topics as animals (farm worker, pet owner/breeder, veterinarian); plants (gardener, lawn worker, arborist); stars and planets (amateur astronomer); geography (long-distance truck driver, worker at AAA); African American or Appalachian culture and history (or any other cultural group); economics (small-business owner, Mary Kay representative). The possible connections are endless.

Favorite Books Workshop

We discovered that many of our primary-grade children knew the stories of Dr. Seuss. Even families with few books at home knew Dr. Seuss. A family workshop focused on his works could build from the familiar and provide a comfortable connection. For older elementary or even middle school students, building a workshop around the Harry Potter books might bring families in. Because of the familiarity, this might be a good starting place for a family workshop initiative in a school. Over time, the workshop could lead to other author studies, perhaps evolving from works the students found particularly engaging.

Diverse Families/One Community

This was the topic of a Family Night Workshop planned and implemented by a group of student teachers at Gayle's school. The student teachers developed several activities to be used in classrooms schoolwide that involved the students and their families in exploring their cultural roots. Suggestions included such activities as creating a family tree, collecting family artifacts, or writing a family portrait. The culminating event was the Family Night Workshop, which invited the families to plot family origins on a huge map of the world, paint a family mural, or create a family flag (Box 4.3).

Box 4.3
Agenda for Celebrating Family Diversity Workshop

Diverse Families, One Community
AGENDA

6:30 Welcome **Sign-in/Family Graph**
 Please chart your family on our graph
 and register for door prizes!

6:45 Performance **"Families Are All Different" and**
 "We All Live Together"
 All students are welcome to perform.

7:00 Family **Family Story Corner, Mural, Quiz**
 game, Flag, and more!

Activities 1. *Family Story Corner* – We invite
 families to relax and read family
 stories from the books provided. You
 may also choose to tell a personal
 family story to other families.
 2. *Family Mural* – You are welcome to
 cut out pictures that represent your
 family at work or play. You may also
 draw or paint your family portrait.
 Don't forget to include the name of
 your family!
 3. *Jeopardy* – Do you recall what year
 WalMart came to aGrange? Try your
 hand at recalling facts about
 LaGrange history!
 4. *Family Flag* – We invite your family
 to create a family flag or recreate
 your heritage flag. Samples of
 heritage flags are provided.
 5. *Family Culture* – Create a drawing of
 yourself dressed in clothing from
 another culture.
 6. *Family Letters* – Write a letter to a
 loved one that may live out of town.

*There are board games placed throughout the room for your
family enjoyment.

7:50 Closure **"We Are Family" Group Sing**

 ***Feel free to visit the book fair located in the library**
 from 6-7 pm.

■ TIPS FOR ORGANIZING
WORKSHOPS SCHOOLWIDE

Some schools may want to plan Family Workshops as a schoolwide initiative. Based on our experiences, we have several tips to offer.

- Don't mandate it. We think the "kiss of death" for Family Workshops would be a requirement that all teachers *must* do this. If that happens, teachers will resent the time, fail to understand the real intent of learning from families and connecting that knowledge to instruction, and implement it superficially. The idea simply won't be sustained over time.

> Principals interested in school-wide efforts to have family workshops can find many helpful tips.

- Start small with volunteers. Perhaps one or two teachers or a team of teachers could take the initiative. Nothing breeds success like success, and word about families' participation and the benefits will spread quickly. Also, parents talk with one another, and some who are less inhibited may take the initiative to get something similar started with other teachers.

- Schoolwide doesn't have to mean everyone at the same time. It could mean everyone doing something at some time during the year, maybe when it makes most sense as it relates to particular classrooms instructionally.

- Consider substituting a family workshop for some other program that the school traditionally has provided. Advertise it as a new event!

- Count teachers' planning, implementing, and following up on the workshop as professional development time by building in ways of sharing what's been learned that can impact instruction.

- Connect a family workshop as one part of another event that families are likely to attend. For example, in Gayle's school, the student teachers planned a workshop focused on reading as a part of the school's annual Fall Festival. Many students and their families enjoyed the reading and performance of the *The Ghost-Eye Tree* (Archambault & Martin, 1985) and other activities. Middle school students may want to perform Jack Prelutsky's (1987), *Nightmares: Poems to Trouble Your Sleep*.

FUNDING A FAMILY WORKSHOP ■

With costs for food, materials, child care, presenters, and stipends for teacher organizers, family workshops can be hard on a school's budget. Administrators and teachers need to be creative in exploring all sorts of funding sources. The PTA, of course, is a logical possibility. However, many others exist as well. For instance, perhaps Title I or Professional Development funds could be used, if teachers follow up workshops with discussions and work related to instructional connections. Local foundations or other community resources might be interested in funding activities that focus on creating closer school and family connections. Fund-raising events (too numerous to list!) specifically targeted at supporting family workshops could provide a wonderful opportunity for school people and families to work together on a shared goal. Finally, innovative teachers might explore grant possibilities—locally, statewide, and nationally. The Internet is a valuable resource for looking into what is offered by state and national Departments of Education and foundations.

Sometimes we use the lack of resources as an excuse for not exploring new initiatives. However, it is surprisingly easy to find sources for funding. Also, money tends to be more available if you have a proven track record. Once you've implemented successful family workshops, can demonstrate the difference they have made in providing more meaningful instruction for all students, and have families working with you as advocates for more such programs, grant funding may be more likely to continue the work. Keep in mind, too, that Family Workshops don't always have to be costly. You may find people and organizations willing to contribute time and materials, and popcorn, cookies, and potlucks offer inexpensive food choices.

■ SUMMARY OF TIPS ON IMPLEMENTING FAMILY WORKSHOPS

As we've implemented Family Workshops, we've learned much that might be helpful to others. Several of these tips follow.

- Provide food.
- Provide transportation to and from the event for those without automobiles.
- Get ideas from families in planning the event.
- Provide child care for little ones.
- Make phone calls to encourage people to attend and nudge those you think might not come.
- Don't try to do too much in one workshop. Maintain focus.
- Have something families can take away from the workshop.
- Organize the schedule to allow for transition time.
- Stick to the schedule.
- Don't move people around too much. With a large group, this can be disastrous!
- Provide plenty of time for discussion and questions.
- Be sure to get evaluation comments.
- Provide hands-on activities (especially having adults working with their children, if they are in elementary grades).
- Tap into local resources such as community members, university people, and so on.
- Invite school board members and other community leaders.
- Get media attention.
- Take photos and deliver them to the local paper.
- Think creatively about how to get materials if funds are limited.
- Have a greeter welcome people as they arrive.
- Provide nametags. First names are fine.
- Have a sign-in sheet.
- Involve key parents as liaisons with other parents.
- Provide welcoming comments, emphasizing the importance of the event for everyone.
- Have an involved role for the principal.
- Take pictures to post in the classroom and elsewhere in the school to create interest in future workshops.

- Display work done at the workshop around the school later that week.
- Consider having a drawing for a prize at the end of the workshop and other incentives/rewards for attendance.
- Talk the event up in the days before the workshop. Get the students excited.
- Send a reminder or call the day before or day of the workshop.
- Provide translators for ESL families.
- Tap into the resource of those families who have attended most workshops to help plan future workshops.
- Follow up with a note saying how pleased you are the families attended and provide a way for them to respond with questions or comments.
- Send materials home to those who couldn't attend.
- Take the time to reflect on the experience and record what you've learned, what worked, what didn't work, what instructional connections can be made.
- Get started planning the next workshop!

SUMMARY ■

This chapter provides reasons for planning family workshops, examples to use as models, and ideas about how to begin. These events provide rich opportunities for teachers to learn from and about students and their families, and to use that knowledge in subsequent teaching episodes. Teachers who are experienced in using family workshops in their settings have this suggestion: "Try it!"

5

Reaching Out Through Family Visits

Teachers do not usually consider visiting students' families at home. Their jobs are in the school building. Parents are clients, in one sense, and teachers serve their clients in their own "offices." This is the thinking of many educators, us included for many years. Sometimes, those who do consider making visits to homes worry about safety or believe that the families of their students do not really want them in their homes. These were also views some of us held before deciding to let go of long-held, false assumptions about what families want. For example, we used to think the goal of family visits was to talk about problems or explain to the families what *they* could do to help their child. In the 1970s, Karen made home visits as a part of the Chapter One reading program. But the visits were to tell parents about their child's weaknesses and tell them what assistance the parents could provide at home to help.

In our research project, our goals were and are radically different. Most important, we view parents as the experts on their children, and we seek to learn from the children's families. We visited several targeted children repeatedly across two to four years. And Gayle made visits to every one of her students before school started each year, something she had been doing for years before our project began. We found that these visits were our most powerful ways of

> Gayle: Once you see a home, that picture is in your mind forever. I can go back 10 years and look at a picture of the children who were in my class and see in my mind even now the homes of each child I visited.

communicating with families and bringing the voices of the community into the classroom.

We call our visits "family visits" instead of "home visits" to differentiate from traditional visits conducted because professionals believed something was wrong in the home. They visited homes to check them out or "fix" problems. Instead, we believe that our families hold information that could *help us improve what we do in school*.

Our initial goal in visiting the families of the children was to seek to understand the families' "funds of knowledge" we mentioned in Chapter 1, which is the knowledge and skills that are essential for a family to thrive. For instance, in some families, gardening was an essential skill, while in others it was knowledge of mechanics or crafts. In Chapter 4 you read about how Gayle organized a family workshop around cooking and mathematics because knowledge about cooking was common for many of her families. Later she planned an evening in which many families shared their areas of expertise on a wide range of topics.

> Karen: I know that I got to meet parents I would never have met before who probably would never have come in to school.

Building on learning theory we described in Chapter 1, we collected this information so we could create instructional units that built on what children already knew. (We elaborate on this in Chapters 6 and 7.) However, as you would expect, our visits proved much more fruitful. We not only learned what our families knew and could do, we also learned information that enabled us to reach out to them in unanticipated ways. And in doing so, our relationships and trust levels improved.

For example, one of Karen's students, Valerie, always seemed disorganized. She often neglected to return homework, books, or her writer's notebook. After visiting the family, Karen saw the similarities between Valerie and her family, and Karen "lightened up" a bit with Valerie and became more sympathetic and helpful. She made her a book bag with handles, and encouraged her to keep all school materials in it when at home and to keep the bag on her doorknob.

So, if you plan to venture into this exciting and rewarding work, remember to

- Check your assumptions about what you expect to find
- Keep an open mind before, during, and after the visit
- Know that your own beliefs may be challenged
- Go in with respect and appreciation that the family has opened their lives to you
- View the parents/guardians as the experts on their children, home, and community
- Go in with questions, not answers

■ BUILDING ON FAMILY/COMMUNITY LITERACY

One of the primary concerns of all teachers is raising the literacy levels of their students. We know a strong relationship exists between the literacy levels of parents or guardians and how well students do with reading and writing in school. A strong correlation exists between education levels and

poverty (Grissmer, 1998). But, we must also remember not to make assumptions about our families' literacy levels, either. Many studies have shown that not all poor families are of low literacy (Purcell-Gates, 1995; Taylor & Dorsey-Gaines, 1988; Teale, 1986), and our own study has shown that as well.

Also, families' literacy levels can be misunderstood. What seems to be problematic is the distinction made about what constitutes literacy. Bloome, Katz, Solsken, Willett, and Wilson-Keenean (2000) distinguish between *school literacy* and *community literacy*. School literacy is characterized by practices we see in school—reading as an assignment, completing homework; drilling and practicing with print to "get better" at it. This is in contrast to community literacy, which includes practices that serve a community function—to find something out (what happened to the fired police chief), for entertainment (to find out when the game is on), to run the family more efficiently (writing grocery lists), and so on.

Historically, most educators have worked toward changing home literacy practices to more closely reflect school literacy with the goal of changing families (Gorman & Balter, 1997). Instead, we hope to find out about the community literacy practices of our families so we can strengthen and build on them. If families cook, let's talk recipes! If they like sports, let's share our favorite sports books with the children. If they are mechanics, maybe they can help us understand how to read the car manual or the directions on how to jump-start the car. Literacy must be broadly defined and understood so we can know both the strengths and gaps in our students' concepts and skills.

Here is an example of a gap in literacy understanding. Ellen was challenged recently with her own literacy difficulties. She had just finished giving a workshop on "reading in the content area" (of all topics!) to a group of teachers in a school in Ohio. It was February and very cold and snowy. She had left her car lights on that morning, and when she went to her car at 4:00 p.m., she realized she had a dead battery. She called AAA but learned that it would be over two hours until someone could come to help. A teacher offered the use of her cables, which came with written directions on how to use them. Ellen took them and thanked her, and when she saw the male professional development leader, Michael (who also specializes in literacy), leaving the building, she asked him to help her as well. (Ellen held the sexist view that men are better at solving car problems than women.) Michael agreed to help, although he appeared reluctant. The three professionals lined up the cars and began reading the directions on the cover of the cable bag. Step one says:

> Connect positive (+) contrasting color clamp to positive (+) terminal of discharged battery wired to starter or solenoid. Do not allow positive cable clamps to touch any metal other than battery terminals.

First, there was a vocabulary problem. Clamp? Terminal? Solenoid? The women had to rely on Michael to know what was what. Then, there was a comprehension problem. They all had trouble visualizing the order of the steps or what was meant by certain actions. "Make final connection to engine block, not to negative post, away from battery, carburetor, fuel line, any tubing or moving parts." Huh? The texts they understood well were

"stand back" and "wear protective goggles." Admittedly, all three adults were nervous doing this seemingly simple task that many people do every day without a bit of fear. They had to talk over every step and agree what it meant before proceeding, and all were a bit embarrassed at what they didn't know and had trouble comprehending. Clearly, reading well does not just mean reading books or newspapers. It sometimes means reading to get things done, and there are many ways to be both skilled and deficient in literacy. In our work, we attempt to understand the kinds of literacy practices families participate in and are good at. We want to build on these practices, rather than only introducing "school" literacy.

With a broadened view of literacy, we can learn to appreciate and build upon our students' and families' understandings. One mother, though poor and undereducated, surprised us with her extensive knowledge of art. Ellen was just at that time educating herself about art and was able to ask many questions. One child taught Ellen all about various feeds for farm animals, and his parents were able to explain the exorbitant costs of running a small farm. This child had extensive economic literacy. In Karen's classroom, Jeff had a collection of motorcycles in a curio cabinet, which led to conversation and classroom reading and writing about motorcycles. Ariel, in the same classroom, had vacation pictures in her living room, and when Karen asked about them, she realized the photos depicted a place she had visited many times herself, highlighting a connection between teacher and student that had not been there before. And Charlie, a struggling reader, was discovered to be using a book at home to inform himself about his car collection. This inspired Karen to find more books on cars for Charlie to motivate him to read. These kinds of funds of knowledge can be seen as resources or foundations upon which literacy can be enhanced.

■ WHAT ELSE WE LEARNED

We learned other information from the visits that enhanced our ability to communicate and connect with the families. Most important, we learned about the love that exists in the families, even when outward appearances might have hinted otherwise. We also learned about:

- Each child's family/household composition
- Work lives of parents and guardians
- Daily and weekly schedules and routines
- Learning preferences
- Cultural practices such as celebrations or traditions
- Educational practices such as literacy work or homework procedures
- Parental/guardian goals for the children
- Support the families receive for education and other needs
- Barriers the families face for high student achievement

Knowledge of the families and how their lives operated on a day-to-day basis affected teacher-parent relations and teacher-student relations (and quite possibly parent-child relations). For example, as we described in

Chapter 2, one mother who had initially been confrontational with Gayle shared during a visit that she had lost her job. Gayle took her to the school's Family Resource Center (a social service center housed within the poorer schools in Kentucky) and within weeks, the woman was hired for a new job. Her attitude changed dramatically after that, and she became coopera- tive, spoke with a gentler tone, and was willing to discuss problems without being defensive or confrontational. During the most recent visit, this mother cried when asked what the visits have meant to her. She said,

> It [the family visits] gives me an opportunity to talk to you. It informs. And instead of being right in the school and feeling closed up or whatever, I like being at home. I mean, I feel like we have a good communication, and with the visits, I think I know every- thing that is going on with him [student] at the school, and I hope you feel comfortable with him, with what's going on here. . . . It's kind of emotional for me.

Family Compositions and Schedules

Teachers do not usually learn that a student lives with nine others in a two-bedroom house, or that a parent is in prison, or that a parent is mentally ill, unless they hear the information "through the grapevine." And then, the news is often revealed in pejorative terms. We have all heard colleagues at one time or another gossip about parents while rolling their eyes. Indeed, during our visits similar information was revealed to us. But we were informed because we were trusted, which made the information assume a whole new dimension. We could sympathize and empathize. We could recognize barriers as just that—barriers that can be overcome. We also recognized that we could change how we work with the families because of difficult home situations.

When we learn of the schedules and circumstances of our families' lives, we gain a deeper understanding of the relationship between home and school from the parents' perspectives. We learned how much time all the families had to read to their children or help with homework projects and during what part of the day this gets done. We've learned about who works and when they work and who is without work. We learned of family problems that have interfered with the child's sleep and homework. We learned who cooks dinner and whether they use recipes or read off pack- ages to prepare food. We learned which parents struggle with literacy themselves, and how they compensate. We learned who can give help to their children and how they do it. For example, in Rachel's home, it is the father who does all the "school stuff" with his child, because the mother works long hours.

In some homes, we learned that the family composition and schedule are treasured realities for some of the children. For instance, in Shontay's household, she and her younger sister live with mom, grandmother, and great-grandmother. The four generations of women depend on each other for their daily functioning. Shontay's mother worked and attended university classes. Grandmother did all the cooking, disciplining, and homework checks. She also read to the children every day. Great-grandmother also worked outside the home. In Shontay's journal each day at school, the

lives of these women were revealed as a tightly knit, caring group of women who put the children first. We learned how lucky Shontay was to live in such a household. All this information better informs what we do in school. Gayle said,

> The knowledge I have of the families affects my assignment of homework for one thing. I am more aware of the help they get or don't get, and I am more understanding of the children.

And Karen said,

> I would never have known how scared and nervous Charlie was about coming to school. Mom would usually have to drive him (instead of putting him on the bus), even though his father thought that was wrong. When I found this out, I went out of my way to help make Charlie more comfortable. We [parents and teacher] worked together and kept each other informed throughout this traumatic time for Charlie. . . . The knowledge you gain through knowing the child, the child's parents, and siblings beyond the classroom is extremely valuable.

■ WHAT FAMILIES LEARN FROM US

While our goal was to learn as much as we could about our students and their families in order to improve instruction and achievement, we found that some of the parents had questions for us. Many of the questions concerned how they could help their child "do school" (Dyson, 1984) better. We decided to provide information as requested. It makes sense; there is no reason to "keep secrets" (Delpit, 1995) about what makes students successful in traditional classrooms, even though our goal was to change our classrooms to become less traditional. Delpit, in her book *Other People's Children: Cultural Conflict in the Classroom* (1995), explains that families often already know the strengths of their family and cultural knowledge; they want their children to have the "skills that get them into college" (p. 26).

For example, a parent of one of Gayle's students wanted her to explain how to help her child prepare to share a book with the class, and if it was OK for the parent to help the child present it. One parent asked Karen what books would be most useful for her child to practice reading, so she could more quickly learn the common "sight words." One grandparent asked for spelling words. Some parents requested information about PTA events or schoolwide programs, and some had difficulties understanding the letters or fliers sent home about these events. We answered their questions, and as much as possible, clarified communications from the school.

We also found it especially helpful when we discovered patterns in the families' questions and concerns. For example, as mentioned in Chapter 2, Gayle and Diane discovered that many of the families (especially the mothers) felt unsure about how to help their children with mathematics homework. This insight led them to plan and put on Math Family Night as described in Chapter 4 and then develop follow-up mathematics activities based on that evening's events as described in Chapter 6.

FAMILY APPRECIATION ■

Without a doubt, guardians are impressed with the time and care it takes to make the visits. Not only that, but many of them are relieved that they do not have to go to the school to be "involved" in their children's education. Many commented how much they appreciated the visits and how much we cared for their children, and this became a major factor in the development of trust. For some parents, schooling was not something they were success-ful at and they were uncomfortable in the setting. Yet, all our parents cared about their children's education (whether that initially appeared to be the case or not). *All* value education, though some may not know how to help or have the skills to help. The visits can help diminish these barriers. At the end of each school year, we asked parents what the family visits had meant to them. The responses were overwhelmingly positive.

> I've enjoyed talking to you, and I've learned a lot about Tom. I mean, just listening to myself talk about him sometimes is like, "Wow, yeah, I really do realize that about him." It's good for reflec-tion. (Tom's mother, May 1999)

> I have enjoyed them [family visits]. I think it helps Brent to see you on a different level instead of the classroom, to see you sitting in his own home, joking around. I think it's good for a kid to see the parents and teacher in a different environment than school. (Brent's mother, May 1999)

> I think they are great, but I make him [the child] warn me so I can clean my house. [laughter] But I do think it's great. It makes him excited. He walks the floors, "Are they here yet, Mom? Are they here yet?" He gets so excited when you come. (Chris's mother, May 1999)

> I think it's good. I think it's good for the children to know that, you know, you can interlink with each other and not be afraid or scared or whatever. Be friends. (Liv's mother, May 1999)

ISSUES IN DOING FAMILY VISITS ■

All of us have had some anthropological training, either in graduate school or through participation in this study, and we are aware of some of the complicated practical, moral, and ethical issues that arise when visiting and interviewing the families of our students. Becoming aware of some of these issues is a must before embarking on a project of this sort.

Is It Safe?

We recognize that many educators worry about safety issues in making visits to students' homes. But, we also recognize that this has been an excuse for some educators not to visit. We believe that many refuse to make visits due to fear of the unknown, and many hold unexamined

assumptions about the families and neighborhoods in which the students live. We recognize that a sort of classism and racism exist in many educators such that they believe a place is unsafe without ever having visited that place. Our students live and play in these places and they survive; we will too—while making an impact on the lives of our students.

As we have expressed, some of us had false assumptions about some of our families, and we all had some fears. One of us was certainly uneasy the first time she visited a trailer park. But after one visit, she knew there was little to fear there. Another was uncomfortable going into the home of African Americans as a white person. Another said that she was afraid only one time in seven years of doing regular family visits. The fourth said at first she would not go alone, but now she would go to any of her students' homes alone. We all learned there was little to fear in these situations. This recognition that the homes and neighborhoods of our students *are safe* comes with time. Our understandings about all these issues have developed over years of doing this kind of work. We recognize that it will take time for other teachers and administrators as well.

It also takes a particular kind of attitude. We go into the communities seeking families' expertise on their children. If we went into the homes as the experts, as if we had "truth" to share, or went to teach parents how to be with their children, we certainly would not feel welcome. And in all honesty, we think the families would be justified in resenting us. We know *we* would resent someone coming to *our* homes with attitudes of superiority, no matter how well intentioned the visits.

Appreciating Differences

Our research team had discussed "deficit" and "difference" views of children, and we worked to learn to appreciate differences in our students and build on them. But we also learned information during the family visits that has challenged our own views of the differences. There are simple differences such as how much time the families spend reading books or watching television, but we have also been met with major differences such as racist or homophobic views. We have been confronted with religious beliefs different from our own and different approaches to child discipline. Learning to respect differences can be conflicting at times, and we found we needed time to "process" data by talking with each other about our feelings. This processing time with another who shares your respectful views of children and families is critical for this kind of work and should be built into teaching time.

Time

Without a doubt, teaching in the twenty-first century takes a different kind of work ethic than traditional teaching (Ayers, 1993). And teaching today's kids successfully takes more time (or a different schedule) than the traditional one. We visited families on afternoons and evenings, and we occasionally attended community events on weekends. We were lucky in that the extra time we spent doing this work was compensated with small monetary stipends (about $25 per visit). We recognize that many or most teachers do not have access to grant funds that might compensate them for extra time.

We recommend that interested teachers visit students they are most worried about or least knowledgeable about to get started. We also believe that a redistribution of teachers' time—school sanctioned time—for this kind of work is necessary. For instance, we know of one school in Tucson where the faculty is released once a month for visits to homes. In another school we worked with, teachers have no teaching duties from 1:30 until 3:00 every Thursday, and that time can be used for visits when no meetings are scheduled.

> Gayle: When you are first starting out, you may resent the time that it takes, but once you've done it, you realize the rewards.
> Karen: It's not something that happens overnight. It's a gradual thing where you finally see the relationships and the benefits.

Elementary principal John Finch is an advocate of family visits. In one of his schools, he helped make it easier for teachers to conduct the visits prior to school:

> We had class lists ready before July 4, and we had folders ready for the teachers. They had a sample script, some tips on how to make effective home visits, business cards for the teachers, the class list, the map of the community, and a home visit document log. Before the kids left for the summer, they wrote directions from school to their home. The teachers got six hours of PD [professional development] credit for this. The migrant teacher worked with us on what to say and not to say. We sent out a survey [to parents] in the first Friday take home folder, and the responses were overwhelmingly positive. . . . We knew the kids and the parents better. . . . We saw a decrease in discipline problems because of this.

Middle school principal Dena Kent also recommends family visits. But she also understands the reluctance on the part of some of her teachers.

> [One new teacher told me] that she had 60 students and that she would never have time for that [home visits]. I said, "That's true, 60 would be a lot, but if you just went with your home room and another teacher did the other 30 . . ." The teacher said, "That might be more workable, but I still don't think there would be enough time." This conversation indicated to me three things: (1) She had not had enough experience to know what home visits can be for her, (2) We have not taught teachers strategies for dealing with time, and (3) Only when we can economically compensate teachers for their extra time will we be able to say, "See what you think, and then draw a conclusion. Don't presume this isn't going to work." On the other hand, the people who have had experience with home visits will be the big supporters, but until we provide the new teachers with the opportunity, they will not see the benefit.

Below are other options school administrators, teachers, or other decision-making councils can discuss if there are teachers in the building interested in family visits:

- Use Title I funds to pay teachers.
- Use Extended School Service (ESS) funds.

- Use professional development time or funds.
- Apply for grants (in any area; if it is a literacy grant, visits can be shaped around literacy practices).
- Rework the weekly schedule by adding minutes to each day, so that one day a week teachers are released in the afternoons for visits.

■ DOING FAMILY VISITS: FIRST STEPS AND BEYOND

What makes a successful family visit? First, we begin by viewing the parent or parents as the experts. We seek to learn from them all we can about their child, routines, literacy and other educational habits, and funds of knowledge. We are visiting so *they* can help *us* improve our teaching.

We begin by phoning a parent or guardian, or catching them dropping off or picking up their child, or by writing a letter asking if we could make a short visit to the home "to learn how I can help your child more." The sample letter Karen sent in the fall of 2001 is in Box 5.1.

In Gayle's letter (Box 5.2), sent in the fall of 1996, Gayle adds that she will send the questions she is going to ask, one strategy for easing the minds of nervous parents.

As you can tell from Karen's letter, we like to schedule the visit in the next day or so, so it will not be forgotten or put off. Initially, some parents are reluctant, curious, or distrustful, though most are willing. Giving the adult the list of questions you intend will communicate that the information you seek is about the child. It is the kind of information they want you to know about their child.

Occasionally, we find parents want to meet with us, but prefer we not come to their homes. This is perfectly acceptable, and we cheerfully oblige. We let them choose where to meet us (sometimes they like school, as often not). Some want to visit outside the home (on the porch or in the backyard), and we do that as well. Nearly all parents have eventually suggested we meet inside their homes, after a few visits when they have learned to trust us. In summary, to get started:

- See parents as the experts.
- Schedule the visit.
- Give parents questions ahead of time, if they want them.
- Meet where they want to meet.

On the first visit, we dress as we are normally seen—not up or down, but as parents see us on a regular basis. We plan to stay only about twenty minutes, but try to let the family guide us about visit length. We keep in mind that they have busy lives and are generous to give us the time to meet with us. We attempt to make the interview like a conversation, so we are sure to share information about ourselves, as shown in Chapter 2. During the first visit, we have used questions developed by our state department and designed to learn about elementary students, which include,

Box 5.1

Dear

I would like to make some family visits throughout this school year. I want to do this so that I can learn more about your child, as you are the one that knows him/her so well! I feel that the more that I know about your child, the better I can improve my instruction so that it will best meet your child's needs. I firmly believe that by working together your child will make great achievements and progress this year.

These visits will be short as I know everyone has such busy schedules. I'd like to stay about 20 minutes, allowing us time to talk about your child. I will be interested in finding out your child's interests and how he/she spends his time outside of school. Please don't go to any trouble, as my visit will be short. I'd love to stop by, soon, if at all possible. If you would rather meet elsewhere, that is fine. Just let me know. I'd like to come by right after school, around 4:15. Please let me know if there is any day next week that will work for you. If that time won't work for you, let me know when would work.

This will be very casual as I really just want to get to know your child in a deeper more meaningful way. It would be great if your child could be there, too. I thank you and look forward to our visits together.

Sincerely,

cut off and return lower portion
**

_____ I can't meet next week at 4:15, but I could meet at_____. (include time and date)

_____ I could meet with you next week at 4:15 on _____. (day)

_____ _____

Your name Your child's name

- How would you describe your child? (Use child's name.)
- What are some things she is interested in? What does she like to play?
- Who are her friends?
- How does she get along with others? Siblings? Friends? Adults?
- Does she have responsibilities around the home?
- What is she good at?
- How does she react when she is upset?
- Does she like books? What kind?

Box 5.2

August 5, 1996

Dear Parents:

I hope you have been having a good summer. I've enjoyed time with family and friends and have also enjoyed making plans for your child's year in our primary classroom. One thing I always do before school starts is schedule a time for a family visit. I have found that this works so well in helping children feel comfortable and look forward to the first day of school. I also like to take a picture of the child during this visit for our welcoming bulletin board.

In the next few days, I will be calling to schedule a time during August 13-22 that is convenient for you. When I come to visit, in addition to meeting your child and taking the picture, I would like about 20-30 minutes of your time to get some ideas from you about what your child likes and can do at home. All of the primary teachers have these parent conversations, but they are scheduled during September at school. I thought that since I was visiting anyway, I would save you the time of making arrangements for a later visit.

This conversation is a way for you to share with me about how your child learns and what your child enjoys doing outside of school. As an expert on your child, your information will help me provide ways of best meeting your child's needs. Once school starts, I'll follow up with a conversation with your child about things he or she is interested in and would like to know more about. With this letter, I've enclosed a list of questions for you to think about before we meet. These will help get us started with our conversation.

When I visit, I may have one of the university students with me who will be at LaGrange this year as part of their program to become elementary teachers. Also for the visits to the children entering school this year, I will have with me Diane Kyle from the University of Louisville. We have worked together for the past five years on studying children's learning. We are very excited to have the chance to continue this work during the next few years, and we want to spend a few minutes explaining the project.

The beginning of a new school year is always an exciting time— for teachers as well as children! I am looking forward to this next year with your child and with you. You'll be hearing from me in the next few days, and I'll see you soon.

Sincerely,

Gayle H. Moore

P.S. If you don't have a phone so that I can call you, please call me at_____.

- Does she like to draw, color, write? What kinds of things? How often?
- Does she like to sort things, organize, measure, count?
- What are your goals for her this year at school? What would you most like her to learn?
- Is there anything else that we should know that can help us during the school year?

When we finish this interview, we reread what we have taken down to give parents a chance to add to or revise their responses.

In Vickie's middle school, the questions initially asked are collected through a survey and then later discussed during the visit. These include,

- List five words that best describe your child.
- What motivates your child?
- What upsets your child?
- What activities does your child participate in?
- How would you rate your child's study habits?
- What study skills does your child need to develop?
- In what academic areas is your child interested?
- What particular academic areas would you like to see stressed?
- What social skills would you like to see developed?
- Does your child have any problems I should know about?
- Other comments or concerns?

While in the homes, we also take note of the surroundings, and often use the physical environment as conversation tools, as we talk about their collections, family pictures, furniture, pets, or other household members. Sometimes we just chat and other times we play with the animals or children. We never ask to see the rest of the house and always ask the parent first if the child invites us to his or her bedroom. During the first visit, we also like to take a photograph of the child, if the guardian allows, so that we can use the photograph in the classroom. We like to hang photos of children so that the classroom feels like theirs.

Elementary principal John Finch knows the trepidation teachers feel about family visits. He developed a series of training sessions for them, complete with tips and sample scripts. We think some of them may be helpful to you. Box 5.3 shows a brief report of a training session, and Box 5.4 shows some tips and thoughts to consider that he provided for teachers.

While our practice is to phone or write ahead in order to make an appointment with families, we think "stopping by" unannounced can be OK as well, as long as the visits are very short and we do not expect to be invited in. In Box 5.5, John Finch provides words for teachers to use when they make these kinds of visits. Of course, teachers can create their own script, but having a sample of the initial words to say when first approaching the families can ease the nervousness many feel.

Box 5.3
Improving Parent Involvement Through Home
Visits Training Component

The teachers had three hours of classroom instruction to prepare for the visit. Many were uncomfortable about meeting parents in their homes. Tips to make them and the parent more comfortable were discussed. Allowing time for the parent to discuss concerns they may have was stressed. Advice on how to make an effective but short home visit was given. Script outlines were developed to help include beneficial information. Such information includes times during the day when the teacher was available, supplies the child would need, and homework policies. Other aspects covered were proper documentation of time, directions to students' homes and evaluation for the project.

Much of the training focused on how to make friends and influence people! The visits were compared to someone running for political office. If you want the public to support you, then you're going to have to win their vote. If you want parents to become more involved in their children's education, you often have to help them take the first step.

Box 5.4
Tips for Making an Effective Home Visit

- Know the parent's first and last names
- Identify yourself
- State your purpose

Thoughts to Consider:
- Keep an index card listing the parent's name, child's name, and address
- Rehearse your script before arriving
- Don't visit when it's raining
- Dogs—always check for them before you get out of the car. Honk if you are uncertain about the dog's demeanor. Let the parent know that's why you honked rather than coming up to the door.
- Don't take it personally if

 1. They don't invite you in
 2. You have caught them at a bad time
 3. They seem ill at ease

- Give the parent an opportunity to talk to you
- Be friendly and smile

Box 5.5
Sample Script

"Hi, Mrs. Smith? I'm Terry Warnick. I'm going to be Mary's teacher this year. I just stopped by to introduce myself and to let you know that if you have any questions or concerns during the school year, don't hesitate to call me. Here's one of my cards. I've written on the back the best times to get in touch with me. I apologize if I've caught you at a bad time.

"I brought along a list of supplies that Mary will need this year. I know it can be hard to find some of these things after school begins. I should also mention that I give homework every night but Fridays. I'll send you a note if Mary doesn't have any. While I'm here, is there anything you would like me to know about Mary?

"Do you know about the picnic on the 14th? Great. I hope you can come. It's really been nice to meet you, Mrs. Smith, and I look forward to seeing you during the school year."

One principal in Lexington, Kentucky, Sandra Wilson, attempts to visit all 180 of her families before the year begins. She does this by walking the streets of the neighborhoods and staying just a few minutes at each home (Deffendall, 2001).

John Finch also provided teachers with a follow-up evaluation that they can give parents in order to get feedback about the success of their visits (see Box 5.6).

Despite the issues and logistics involved in doing this kind of work, we all agree that the rewards are worth the challenges. Making family visits builds a bond with the students that can be obtained in no other way. As Gayle said, "Knowing the children in this way makes you really want to try harder as a teacher. It makes you appreciate each child in ways you may not have otherwise. It is also a way of being a link with other resource agencies in the community." Karen said, "It strengthens the bond you have with the family; it strengthens your commitment to them so that you do everything you can for their child so that the child is happy, loved, learning, and successful." This kind of work is about understanding our students at a deep and contextualized level in home and school, focusing on what they do know, not what they lack, and then changing our practices to build on this knowledge. Without a doubt, we all agree that visiting the families, when done with certain attitudes and actions, is by far the most valuable experience we have had in teaching. Nothing comes close to doing what the visits can do.

SUMMARY ■

We knew in writing this book that for many teachers conducting Family Visits would be the most challenging way of reaching out to families. It

Box 5.6
Follow-Up Evaluation

Dear Parent,

We, the staff of _____ Elementary, want you to be comfortable with the school and your child's teacher. We hope the home visit made during the summer was helpful to you.

Please answer the questions below so we will know what you liked or disliked about the visit. Since the visits were not scheduled, we realize not all the items listed may have been addressed.

1. Was the visit you received from your child's teacher helpful to you and your child?
Yes _____ No _____ Somewhat _____

2. Was the visit helpful to you in any of these ways?
_____ Understanding about homework
_____ Meeting your child's teacher
_____ Your child meeting his or her teacher before the start of school
_____ Getting a list of school supplies early
_____ Information about contacting the teacher during the school year
_____ Having an opportunity to talk to the teacher about your child
Comments: _____

3. What would have made the visit more beneficial to you?

4. Did the home visit make you feel more comfortable about calling or coming in to see your child's teacher? Yes _____ No _____

usually takes persistence and the building of trust through other activities before visits are successfully achieved. We hope some make the effort, at least with the children teachers feel they know least about or worry most about.

6

Modifying Instructional Practices to Increase Family Involvement

In Chapter 1 and throughout this book, we have emphasized that the goals of positive family involvement include more than improving relationships. The goal is, equally and ultimately, to raise student achievement. Decades of learning theory and key studies that have shaped what we know about how young people learn have taught us that students learn by connecting new information with what they already know (Bruner, 1996), and that the construction of new understandings occurs through dialogue and collaborative work with others (John-Steiner, 2000; Tharp & Gallimore, 1993; Vygotsky, 1978; Wells & Chang-Wells, 1992).

In our work with children of diverse populations, we knew that we must make conscious efforts to connect our curriculum with the knowledge students had from their home and community lives, and that we must create classroom opportunities for dialogue and group work. Thus, our instruction has focused on the national standards of professional organizations such as National Council of Teachers of English (NCTE, 1996), the International Reading Association (IRA, 2000), the National Council of Teachers of Mathematics (NCTM, 1989), and the Center for Research on Education, Diversity, and Excellence (CREDE, 1997) standards for instruction with diverse populations. Our move to focus on these national standards was

also based on our lack of success with traditional instruction for children of poverty and those whose cultural backgrounds differ from schools.

■ THE LIMITS OF TRADITIONAL INSTRUCTION

It is probably not surprising to many readers of this book that our perspective on effective instructional practices differs from traditional instruction. To view students and families in the ways that we have learned to view them—that is, with respect for their own community knowledge and ways of knowing—requires the belief that old ways of teaching will not work. The idea of teachers imparting facts, concepts, or skills *we* consider relevant does not match with what we know about how people learn. Instead, we know that our students come to us with a wealth of knowledge and skills that we must build upon.

As described in Chapter 1, the work that we do with families and in classrooms is grounded in our understandings of the wide differences or "discontinuities" between traditional schooling and the home cultures of many students. The differences between the school and community cultures may disenfranchise minority students and complement the achievement of the mainstream community. Many children's cultural ways of interacting have been viewed in schools as evidence that the students need remediation. With no negative intentions, many teachers have unwittingly undermined their students' cultural ways of knowing and helped to create school failure (McDermott, 1987).

Thus, building instruction around national standards that recognize meaningful, authentic instruction that connects home and school may help eliminate the failure too many children experience. This book is built around one of the five primary standards developed by CREDE (1997), although all five are essential for increased student achievement:

1. Joint Productive Activity: Teachers and Students Producing Together

2. Language Development: Developing Language Across the Curriculum

3. Contextualization: Making Meaning by Connecting School to Students' Lives

4. Cognitive Complexity: Teaching Complex Thinking

5. Instructional Conversation: Teaching Through Conversation

Evidence of the effectiveness of these standards in elementary, middle, and high schools across the nation comes from a variety of studies from a variety of perspectives of a multitude of diverse populations. Tharp (2001) summarized these claims and evidence by illustrating several "hand-crafted" small programs (Lee, 1995; Moll, Amanti, Neff, & Gonzalez, 1992) that implement some of the standards. Other long-term programs with systemic evaluation data (Carpenter, Fenneman, & Franke, 1996; Newman, 1996; Newman, Secada, & Wehlage, 1995) indicate high rates of achievement. Full implementation and its effectiveness for all the standards was first documented in the KEEP project mentioned in Chapter 1, and later

documented in Arizona and other states across the country (Jordan, 1995; Vogt, Jordan, & Tharp, 1992). Our study focused on all of these standards for teaching; however, this book focuses primarily on the standard of contextualization.

CONTEXTUALIZED INSTRUCTION ■

One increasingly popular area of work, upon which this book builds, is that championed by Moll and González (1993), who use families' "funds of knowledge" upon which to build school curricula. In funds of knowledge work, teachers use a variety of ways to assess families' knowledge and build activities and curricular units around those topics (Kyle, McIntyre, & Moore, 2001; McCarthy, 1997; McIntyre, Kyle, Moore, Sweazy, & Greer, 2001; McIntyre, Rosebery, & González, 2001; Moll & González, 1993). This standard is not unlike the standard issued by IRA (2000) that states: *"Excellent reading teachers assess children's individual progress and relate reading instruction to children's previous experiences"* (p. 1). In the description of this standard, it states,

> They (teachers) are familiar with each child's instructional history and home literacy background. They understand the importance of using such information as one source of measuring children's reading progress. All of this knowledge is used for planning instruction that is responsive to children's needs. (International Reading Association, 2000)

Contextualized instruction motivates students and builds on what the children already know, increasing the likelihood that the children will learn (Johnson, 2000; Tharp, Estrada, Dalton, & Yamauchi, 1999). Indicators of the CREDE standard of "contextualized instruction" include the following. The teacher

- Begins activities with what students already know from home, community, and school.
- Designs instructional activities that are meaningful to students in terms of local community norms and knowledge.
- Acquires knowledge of local norms and knowledge by talking to students, parents or family members, community members, and by reading pertinent documents.
- Assists students to connect and apply their learning to home and community.
- Plans jointly with students to design community-based learning activities.
- Provides opportunity for parents or families to participate in classroom instructional activities.
- Varies activities to include students' preferences from collective and cooperative to individual and competitive.
- Varies styles of conversation and participation to include students' cultural preferences, such as co-narration, call-and-response, and choral, among others (CREDE, 1997)

> Gayle: What's important for children to learn is to feel comfortable, accepted and valued, not intimidated; to know that the teacher values them and their family and their experiences. I don't think it matters nearly as much about "scope and sequence" as it does to help that child feel comfortable and *fit* in school.

Contextualized instruction, then, is all about knowing the students, knowing what they know, and building from it. In this chapter, we show how elementary and middle school teachers build classroom curriculum from what their students know. They purposely find ways to involve students and their families in joint, collaborative work that involves extensive dialogue among participants, thus utilizing what is known about how students learn.

In previous and subsequent chapters in this book, we have illustrated how we have implemented many of the above standards. For instance, we have acquired knowledge of local norms and knowledge through our family visits and community presence as described in Chapters 2, 3, and 5. We have provided opportunities for families to participate in instructional activities through Family Workshops as described in Chapter 4. We will illustrate in Chapter 7 how alternative styles of homework can also meet several of the standards. In this chapter, we focus on how teachers begin activities with what students know, design activities that are meaningful based on local knowledge, vary activities to include students' preferences, and vary studies of participation to meet the needs of all students. When implementing these standards, we have found that we do this in both *incidental* and *intentional* ways.

Incidental Contextualized Instruction

Some of the changes in our instructional practices came about incidentally as we became more familiar with our students' out-of-school lives. Of course, even incidental instruction occurs only when our awareness as teachers is heightened by the importance of making explicit connections between our planned curriculum and what we know about students. For example, two of Ruth Ann's students, Sarah and her brother, raise goats, doing all the feeding themselves. When Ruth Ann read a book about farm animals aloud to the class, she stopped to invite Sarah to tell all she knows about the care and feeding of goats. When a new baby was born in the family of one of Karen's students, Karen encouraged Jeff to share the experience with the class. When studying the ocean, Karen asked Ariel to share her experience and knowledge of salt water. And Sammy was the expert in Ruth Ann's class in the study of agriculture. Of course, incidentally contextualized instruction is not fully incidental. As teachers, we must plan on heightening our awareness to the opportunities that arise in our classrooms to make the connections between students' homes and school explicit. We must plan to be incidental. Karen reflected,

> The family connections come to your mind in the middle of instruction, the middle of a story, the middle of a conversation. If you let the students know you are connecting with them, it makes them feel valued. Little things, like the name of a pet, can go a long way. They think, "Oh, man, she knows that about me," or "She cares enough to bring that up again."

Intentional Contextualized Instruction

We have also gone beyond incidental to plan more elaborate lessons and courses of study that build on families' funds of knowledge or students' interests. The following ideas range from easy-to-make connections to elaborate, time-intensive units that involve students' families.

Literature Connections

Books are powerful tools for learning. We knew that to create a classroom setting congruent with the cultural backgrounds of our students, we must build a collection of both fiction and nonfiction books that represent our students' cultural, ethnic, and racial backgrounds, their family structures, housing arrangements, geographic locations, interests, and family events (new baby, sick pet, etc.). Not only does having a variety of literature help us meet our goal of contextualized instruction, it is one of the NCTE (1994) standards and one of the IRA (2000) standards for excellent teaching.

We made special efforts to find books we knew particular students would enjoy because of something we learned about them through family connections. For instance, Gayle used many books about grandparents in recognition of the strong ties many had with their grandparents. Karen knew her student, Justin, was interested in cooking. His mom was a cook by profession. Karen recalled,

> I encouraged him to take home a children's cooking book over the weekend. There was a lemonade recipe in there that he tried. He said he tried it, and it wasn't too good. After discussing it, he tried again, and it was fine.

Shontay was the only African American child in Stacy and Ruth Ann's classroom and one of only fifteen in the school of 1,300 children. Yet her teachers took considerable time to find her books by and about African Americans. Shontay had become the classroom expert on the Civil Rights Movement and on the most of the famous people who made contributions to the movement in the 1960s and 1970s. She also starred in the class play about Rosa Parks.

To involve families and build on home experiences, these two teachers also decided to do a study of Dr. Seuss and his books. This involved finding and reading as many of his books as they could in a two-week period. The teachers informed the parents and guardians about the plan. Stacy said,

> Everybody was thrilled. We all had common ground, and everybody had Dr. Seuss books at home. The parents felt very comfortable because they felt like they had added something to their child's instruction because they were the ones who told us about Dr. Seuss. They were glad to help and share their books and we sent books back and forth from home to school.

In Vickie's middle school, students were invited to read a biography over the summer before seventh grade to be used as a way of introducing oneself to the classroom at the beginning of the school year. Students were asked to compare and contrast the subject of their biography to themselves, their families, and their community. This project allowed students

to choose books they wanted to read and to make personal connections with the author or subject of the book and to consider how different people react to challenges placed before them. Many students reported that one of their parents helped them select a book based on his or her interest. Often the subject of the book was the parent's age and usually the character was familiar to the parent. Occasionally, we heard that parents read the book and discussed it with their child.

Sometime during the first week of school, students were divided into groups of five to share posters depicting the characters with their group members. Students were able to introduce themselves and their families through discussion of a famous person. Students also learned about four other books they could choose to read that year. In Resources A and B, we provide annotated bibliographies of good, culturally sensitive children's books.

Instructional Units

In Gayle's classroom, during a study of neighborhoods, they used their own as a reference point, building a clay neighborhood complete with school, post office, library, and so on. Within the unit, she taught about shelter and she referred to the different kinds of homes in which the children lived and that were represented in their model neighborhood, such as apartments and trailer parks.

Learning about her students' strong connections with grandparents, Gayle built grandparent interviews into her unit, Change Over Time. She was able to build several instructional extensions from the information the children gathered with their surveys, as Photo 6.1 illustrates. The unit's culminating event included an afternoon when the grandparents visited and the children presented what they had learned about the changes that had occurred since their grandparents were young children.

The letter in Box 6.1 illustrates Gayle's invitation to this important event. As described in Chapter 7, Karen invited families to become involved in the students' "expert projects," in which the children had to become an expert on some topic and share it with the class. The children had to think of a topic or skill and teach what they learned to the class.

Stacy and Ruth Ann's students lived in a rural area where many of the families had knowledge of farming, a few were hands on others' farms, and a few had dreams of owning their own small farm one day. They planned lessons around agriculture and culminated the unit with a community-wide Agricultural Field Day event in which community members brought equipment and animals used in farming. The lessons varied from sorting and classifying seeds to understanding what it takes to feed one cow for a year (McIntyre, Sweazy, & Greer, 2001). Both skills and concepts were standards for Kentucky's mathematics and science curriculum.

A seventh-grade mathematics teacher developed a unit on measurement and design in which he had his students design their own dream house, using mathematics and architectural practices (Ayers, Fonseca, Andrade, & Civil, 2001). Two middle school science teachers taught about

Photo 6.1
Student sharing
interview results with
grandmother

sound waves using their students' own music (Conant, Rosebery, Warren, & Hudicourt-Barnes, 2001).

At Vickie Wheatley's middle school, students study Careers and Practical Living. For this unit, she invited parents and guardians to share their careers with the students and conduct mock interviews with them. In class, students learned how to fill out job applications, prepare for a job interview (using appropriate language, dress, etc.), the questions to expect, and how to answer them. Parents were given sample questions and encouraged to ask their own. They were asked to provide written feedback to the student using a rubric developed by the teachers.

Students took the interviews seriously. They dressed up and were nervous. They overwhelmingly said they appreciated the session and learned a lot. Parents were enthusiastic about the process as well. They enjoyed sharing their expertise and said they were impressed with the preparation and seriousness of the students.

Box 6.1

March 25, 2001

Dear Parents,

We are enjoying our study of how things have changed since our grandparents were our age. Thanks for all you have already done to make our study interesting.

To end our study connected to our grandparents, we would like to have as many grandparents as possible come to school and share a story about when they were in first or second grade. Please help your child *invite their grandparents* to have lunch with us on *Friday, April 2, 2001,* and then spend about an hour after lunch in the classroom. We would like to share with them some of the things we have learned and have them share with us about their life at age 6,7, and 8. Nothing formal, just sit in a circle and talk. *They should be here by 11:15.* Lunch is 11:28-11:50. Maybe we can squeeze in a few extra minutes for our special lunch. We should be finished by 1:15.

I realize not all grandparents live close enough for this visit to be possible, but many do, so I hope you will help them make this a special time for our class and your child.

Thank you for all you continue to do to help make this a wonderful year for your child. I do so appreciate the work you do on the Home time each week. Nearly everyone has turned in homework on time *every* week. That is so helpful to me. So many of you have been especially supportive of every school program this year. This means so much to your children.

Please let me know how many will be coming so I can make lunch reservations for them.

Sincerely,
Ms. Moore

_____(child's name) will have _____grandparents attending our Grandparent Lunch on Friday, April 2, 2001. Please order Entrée #1 _____ Entrée #2 _____ Salad Bar _____

At Dena Kent's middle school, many of the students and their families use tobacco regularly. Some of the teachers worried about doing a health unit showing the dangers of tobacco when so many of the students and their families are users, and they went to Dena for advice. The teachers also wanted to spruce up the school and provide buckets for cigarette butts. Dena wondered what parents would think about a unit on the harmful effects of tobacco when many families' income depended on it and whether they would view the buckets as a deterrent or incentive to continue smoking. She surveyed the parents, beginning with school bus drivers, who communicated that they, too, wanted their children to stop

smoking or never start, and they wanted a more attractive school building. They thought the buckets were a good idea. This small step gave teachers the confidence to begin to talk more openly about tobacco and to invite parents in to speak with the teenagers about it. The teachers began with a meeting introducing the curriculum to the parents. Surprisingly, Dena and her teachers received no negative feedback from families about this unit.

Family Night Connections

As described in Chapter 4, Gayle and Diane organized a Math Family Night at Gayle's school, in which families brought in food from favorite recipes. The recipes were collected and distributed, and the next day Gayle and Diane created complex mathematical problems for their second graders using the recipes. These problems and activities illustrate two standards developed by NCTM, solving authentic problems and using the language of mathematics to do it. One example of the problems follows:

Butter Needed

Jasmine's sugar cookies ¼ cup

Dr. Kyle's hermit cookies 1 cup

Sara's no-bake cookies ½ cup

Joshua's hula cake icing ½ cup

Cleo's fruit crunch ½ cup

How much butter would be needed for all recipes? If you had only 1 and ½ cups butter, which recipes could you make?

The children worked as partners or small groups to solve the problems. They were expected to present the results of their work in a visible way and explain their mathematics strategies to the rest of the class, illustrating joint productive activity and language use, two standards of the Center for Research on Education, Diversity, and Excellence (CREDE). And of course, since it extended from a shared event and the problems were contextualized in an authentic experience, it also illustrates the third CREDE standard—connecting instruction to what students know. The lesson involved mathematics, writing, art, speaking, and group work. Yet, the children saw it as fun (for more on this evening and its following activities, see Kyle, McIntyre, & Moore, 2001).

Community Events

As mentioned above, Ruth Ann and Stacy hosted Agricultural Field Day, which has become an annual community event. Each year, there are between thirty and fifty "stations" that teach something about agriculture. Some of the stations sport live animals or farm equipment, display crafts or music, or they illustrate processes or concepts relevant in farming (e.g., milking, germinating seeds). Most often adults present information and conduct demonstrations, but sometimes older children or teenagers will present as well (for more on this event and the unit of study, see McIntyre, Sweazy, & Greer, 2001).

In Dena's rural community (the same community as Ruth Ann and Stacy's), the homecoming parade is a big event. As a new principal, she was expected to enter a float in the parade, and she had little idea of where to begin. She enlisted the help of teachers and parents of her school community. They realized the potential for teaching mathematics, science, agriculture, and economics by putting that float together, and the teachers began to incorporate lessons around the float making into the classroom. Parents came into the classrooms to oversee the work and provide assistance and feedback where needed.

Follow the Children

One of the best ways to contextualize instruction is to allow children as a group or as individuals to decide what they will study. Karen had interviewed her students at the beginning of the school year, asking about topics of interest. When analyzing the interviews, she realized that many were interested in learning about animals so she planned a unit on animals. One of her students, Jimmy, showed an interest in TV commercials and this prompted Karen to do lessons on advertising, falsification, and the economics of advertising. When you follow students' leads, they will naturally be motivated and will enhance their literacy skills through reading, writing, and solving problems on that topic.

■ UNDERSTANDING TEACHING AND LEARNING

All the teachers and principals with whom we have worked believe that connecting with children's families and home cultures has led them to a better understanding of teaching and learning. Gayle and Karen reflected on this:

Gayle: [Involving parents in the curriculum] has given me a greater understanding that learning is constructed; it's based on prior knowledge and connected to something they already know. Those were words to me; it was a theory. But I really saw it as I got to know each child. I thought, here's the curriculum; here's all the things I am supposed to teach these children. I saw that the way I had to do it was that each child had to connect with something they already knew. It was my job to take the curriculum and . . .

Karen: . . . and have it fit the child, rather than putting the child into the curriculum, into the mold, going the opposite way.

Gayle: Or just teaching the curriculum and hoping that you can make the connections. Which is what we typically did. We taught it, saying, "I am going to do this" without even thinking about the needs of the child.

Karen: Going through the textbooks, which is what I did in the '70s. I didn't think once about what kids had done, what they were doing, what their interests were, or their family experiences.

They also see how their instruction can be more responsive, and thus more developmentally appropriate. Gayle explains,

> It is important to understand the needs of each child. The more you know about the child's family, the better you can meet the child's needs. I can see the child's maturity level better when I see the child at home and school.... I can meet the child's needs better if I know what is going on outside the school.

The most important thing to remember is that this kind of teaching can occur successfully only if we really know our students. According to Ayers (1993),

> Teaching begins and ends with seeing the student. The student grows and changes, the teacher learns, the situation shifts, and seeing becomes an evolving challenge. As layers of mystification and obfuscation are peeled away, as the student becomes more fully present to the teacher, experiences and ways of thinking and knowing that were initially obscure become ground on which real teaching can be constructed. (p. 25)

POSSIBLE STEPS TO TAKE ■

To help you connect your instruction to the lives of your students, we summarize this chapter with steps you can take to get started.

- Brainstorm with colleagues how the CREDE indicators for contextualization can happen in your school.
- Survey or interview families at home or school about their interests and find literature for students that support those interests.
- "Walk the walk" as described in Chapter 2, to get to know your school's community; visit the site for historical records. Get students to make the maps of the community and help plan the course of study.
- Share this information and your instructional plan with your students and their families at school or at a Family Workshop.
- Enlist families to suggest topics of study, help provide materials for study, help implement lessons for what is being studied.
- Make incidental remarks about students' out-of-school lives whenever appropriate.
- Develop instructional units around families' funds of knowledge.
- Allow children to select topics of study or ways of sharing what they know from time to time.
- Invite parents and guardians in to teach in areas in which they are expert.

Most important, enjoy your students and what you are doing. Unless teachers find the work rewarding, it will not be sustained. We think developing relationships with students and families and building instruction is very rewarding work, and it is one of the reasons we continue to love what we do.

■ **SUMMARY**

The heart of our book is about increasing student achievement through improved instruction that is based on families' understandings and students' needs. And we have come to view this kind of practice as impossible without improved relationships with students' families. From this insight, we have made gradual changes from more traditional teaching of content and skills to more contextualized and innovative teaching that not only meets standards for students and ourselves as teachers, but at the same time challenges us to make sure the instruction is relevant and motivating for children. We recommend examining your own curriculum standards and making connections with what your families know as a first step toward this kind of teaching.

7

Involving Families in Homework

In the classrooms we have highlighted throughout this book, homework has had to change dramatically in order for students to become more engaged and motivated, essential for increased achievement. While sending an occasional practice worksheet is still okay and even welcomed by many parents, we know that if we continue to send home traditional work, we will continue to get bored students who are alienated from school. In this chapter, we share homework procedures and assignments that encourage (but do not force) family involvement. Nearly all extend from families' funds of knowledge in some way. Many take several days, essential for teaching children to become decision-making, independent learners.

MANAGING AND MONITORING HOMEWORK ■

For many teachers, particularly upper elementary and middle school teachers, the management and monitoring of homework is sometimes as challenging as creating innovative assignments. In Vickie's and Dena's middle schools, it is no exception. A successful technique they use (mentioned in Chapter 3) for clearly communicating daily and long-term assignments is the use of the Agenda, a spiral-bound calendar organized to show all classes for a week at a time. Each day, the teacher posts homework and due dates on the board. The first order of business for students as they come into the classroom is to record this information. The teacher's responsibility is to explain the homework and answer any questions the students may have. Sixth- and seventh-grade teachers often walk around the room to see that every student has accurately recorded the homework.

The Agenda is designed with large blocks of space for two-way communication between the teacher and the parents. Notes from teachers could include positive comments about how well a student has completed a project, been responsible for meeting deadlines, or made a particularly creative contribution to the class. Notes can also help in alerting parents to missing assignments or low test scores, reminders of upcoming tests and quizzes for students who are having difficulty in the class, or requests for conferences.

Students are responsible for accurately recording the information and clarifying any questions they may have. Parents know that all homework is recorded in the Agenda and that their responsibility is to review the homework with their child and sign the Agenda. In the sixth and early part of the seventh grade, homeroom teachers check each morning to be sure the Agendas have been signed. By the second quarter of the seventh grade, only those students who are having trouble completing homework on time are required to have the Agenda signed. However, they are always required to have an Agenda and to fill it out completely in each class.

Vickie comments, "Parents love the Agenda! It is one of their main connections to the daily work of the school." As described in Chapter 2, the Agenda also provides families with large blocks of space within which to ask questions, or to let teachers know of extenuating circumstances, such as illness, family issues, or involvement in competitive sports, that may interfere with their child's ability to complete the assignment. Other messages might include remarks about their child's progress; upcoming trips that may take their child out of the classroom; notification when parents may be out of town and with whom their child will be staying; how much time their child is spending on homework (especially if they feel it is too much); and the occasional positive note or thank you to the teacher.

At Vickie's middle school homework is assigned daily, and students are expected to turn it in on time in order to receive credit for it. A policy like this requires excellent communication with parents about any missing assignments their child may have. The school's SSS (Student Services Specialist) had heard about a program called A.C.E (Assignments Completed Everyday) at the National Middle School Association's annual conference, and the faculty thought it would be perfect for their situation.

The A.C.E. program includes structured assistance for students having difficulty in completing assignments on time. Students with no late assignments in a week's time are placed on the A.C.E. honor roll, which makes them eligible for special privileges. If a child has a late or incomplete assignment, a red slip noting the missing assignment is filled out by the student and taken home for the parent to sign. This gives immediate notification of the problem to the parent. If, on the following day, the late assignment and the note are returned to school, the student receives partial credit for the assignment. If the assignment and note are not returned on the following day, the student is assigned to the Intervention Room where the assignment can be completed and the parent notified.

A letter to this effect is sent to all parents, who sign it and return it to the homeroom teacher. Because teachers keep records of all missing assignments, it helps to quickly identify students who will need assistance with organization or content area skills.

For students who miss more than one assignment in a week, teachers use a letter to the parents called "Late Assignment Alert." This informs the parents of the number of late assignments and requires the student to get

a teacher and a parent signature next to each assignment recorded in the Agenda. The parents are informed that if the teacher's initials are not present next to the assignment, the student did not turn it in, and it must be completed at home. Parents initial the assignment when the child shows them the completed work.

Parents are an integral part of this monitoring system, and they appreciate knowing immediately when their child did not complete or turn in an assignment. Usually, because the parent is aware of the problem, the assignment is turned in the next day, which prevents the child from receiving a zero or from getting too far behind.

TEACHERS DOING HOMEWORK ■

Last year, Ellen's sixteen-year old nephew was assigned to "write a novel." He had five weeks to do this and little instruction. He came to Ellen for help. She couldn't believe he was assigned this and insisted he must have it wrong. A sophomore in high school, writing a novel? When she found out that it was indeed a true assignment, she was horrified for her nephew and tried to help. Because there was no real communication or trust between home and her nephew's school, Ellen did not dare complain. How she would have liked a homework comment sheet as described in Chapter 3.

One idea for teachers in understanding the appropriateness of a particular assignment is to do the work themselves. One of Ellen's colleagues at the University of Louisville teaches composition to freshmen. She plans elaborate assignments that involve several steps she believes will most help her students improve their writing. Then she does the assignment herself, with her students. This allows her to experience what they are experiencing, to understand the difficulties they might have along the way. She is also demonstrating the process herself, letting her students know that writing takes effort, even for accomplished writers like herself. It would have been interesting if Ellen's nephew's teacher took this approach. Would she have written a novel?

FAMILY INVOLVEMENT IN HOMEWORK: ■
CREATIVE ALTERNATIVES

In this section we provide a few examples of homework assignments that involve families. We encourage you to select and adapt what is most appropriate for your students.

Me Boxes/Me Notebooks

A "Me Box" is a container (bag or box) with artifacts inside that illustrate the owner and creator of the box (Photo 7.1). It is a way for the owner to share something about him- or herself that may not get known otherwise. Gayle and Karen have both used this strategy as a way for students to get to know one another and build classroom community.

Photo 7.1
Sharing a "Me Bag"

Karen prepares a Me Box at the beginning of each school year (although doing it mid-year may be helpful as well). In her most recent box, she included, among other things, photographs of her family, her favorite book, her grandmother's necklace, a candy bar, and a pencil. When she shares her box, she explains why each item is included, attempting to demonstrate how artifacts can be tools for representing ourselves. Karen explained that she chose the necklace because it illustrated a lot about her. She loves jewelry, and she had a meaningful relationship with both her grandmothers. And she has strong family ties. When she held up the candy bar, she simply said, "I love candy—sweets in general." She also shared that she collects interesting pencils.

After the demonstration, Karen invited the children to create a box representing themselves. She explained the procedures in her "News and Notes" (see Chapter 3) and encouraged families to help. She told the kids they could use cereal boxes, shoeboxes, or any kind of box. If they didn't have a box, they could bring it in a bag. Students had several days in which they could finish the project, and as they brought it in, they shared. All children had an opportunity to sit in the Author's Chair (Graves & Hansen, 1983), share their items, and explain their decisions for selecting their artifacts. After all children have shared, Karen provides a time for each student to take a spot in the room near his or her box and allows the children to walk around the room and talk with each other about the boxes (fair style). While many children struggle with understanding representation (some seem to want to bring in everything from their room!), other

children take the time to be discriminating. One child, Justin, included a page from his "Day Planner" (see Chapter 3) indicating his excitement about his teacher making a visit to his home (see Chapter 5).

Older children might not be comfortable bringing in a cereal box with artifacts inside. They might choose to decorate a notebook (perhaps their "writer's notebooks"). They could be invited to take photographs of key people, places, and events that define who they are. If they can't photograph, using magazine pictures and words that illustrate themselves works. Family members could help by suggesting to the student what most exemplifies his or her life.

Expert Projects

Karen wanted to communicate to children her belief that everyone is good at something. She also wanted the children to develop oral language skills. She devised her "Expert Project," and encouraged family involvement (Box 7.1). She explained that the children were to show their expertise or talent in some area. The children had to prepare a presentation for the class in which they were to teach something to the other children. They began by brainstorming things they were good at (with parents, if they chose). Then, they selected their topic, prepared a presentation, practiced it, and then taught the class (Figure 7.1). Afterward they filled out a reflection form on this assignment. Karen graded the assignment using a rubric she had shared with the children and parents (Table 7.1).

Box 7.1

Expert Project

A homework assignment for next week

We are all good at doing some things. This project involves picking one thing that you are really good at or an "expert" at and teaching it to our class. Some of us are good at magic tricks, whistling, card tricks, sewing, cooking, playing a certain game, knowing a lot about a certain thing, knowing a lot in tying, origami, napkin folding, dancing, making things, hand games, etc. You need to think of things that you can do well and pick one that would be possible for you to teach our class. This is really homework for next week but I wanted you to start thinking! Start brainstorming ideas and keep thinking until you come up with something! I'm letting you know of this assignment now, so that you will take the time to really think about it! This is due next week. You may be ready to teach the class any day next week and may do so, although you need to be ready no later than Friday. I will model something that I am an expert at so they will get an idea of what is expected. I also have developed a rubric that you may look at to see how I will grade this project. The Me Boxes were such a great thing, I wanted to be sure to include other projects this year in which we get in front of our classmates and communicate with them!

Figure 7.1
Expert Project

EXPERT PROJECT Title _____

Name _____ Date _____

Complete. Turn in on the day you are ready to "teach" the class. Be sure you have practiced and have all the things you need to teach us.

I decided I'm an expert at _____

Some of the other ideas I thought of and considered were _____

I chose to teach _____ because_____

I learned how to do this _____

I prepared myself (got ready so that I could teach the class) by _____

I practiced teaching it on (list names of people you practiced on) _____

The materials that I am bringing so that I can teach this project are _____

Table 7.1
Performance Rubric

EXPERT PROJECT Title _____

Points Earned _____

Name _____

Date _____

Performance Criteria	Rating			
General Criteria				
Name on project paper	5	3	1	0
Date on paper	5	3	1	0
Work is neat	5	3	1	0
On time	5	3	1	0
Specific Criteria				
Completed project paper	10	7	4	0
Had materials needed	10	7	4	0
Taught class a specific thing	10	7	4	0
Productivity Skills				
Student showed understanding of what he/she was teaching	20	13	6	0
Spoke clearly	10	7	4	0
Gave clear demonstrations and instructions	10	7	4	0
Acted seriously	10	7	4	0

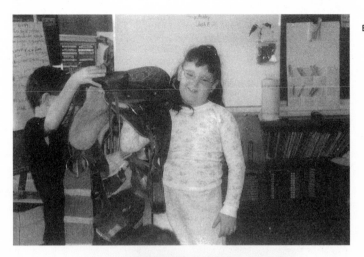

Photo 7.2
Expert about horses

Photo 7.3
Expert about string
games

The expertise in Karen's classroom varied widely (see Photos 7.2
and 7.3). Ashley showed how to plant something. Justin demonstrated
how to do string games such as Cat's Cradle. And Adam explained and

INVENTION PROJECT

Think of some sort of problem or inconvenience that you'd like to fix. It needs to be practical, something you could really resolve. Make up an invention that solves the problem. Remember all the inventions in *The Gadget Wars.* Each one of the inventions that Kellie and Albert Einstein Jones made, were for a PURPOSE. You might think, well, I'd like to invent something to do my homework for me. That would be something that you couldn't invent. Think of something that you COULD resolve! Brainstorm a bunch of problems of inconveniences first. Then think of possible ways to solve them. On a sheet of paper or note card, tell the problem that your invention is taking care of. Name your invention. Put your name on the paper. Choose one to actually invent! You don't need to think of big, major problems. Think of smaller ones! Look at the rubric to see what you need to be sure to include. A total of 80 points can be earned. These are due this Monday, Feb. 7.

INVENTION RUBRIC

	Possible Points			
Invention is completed on time.	5	3	1	0
Paper about your invention is turned in on time.	5	3	1	0
Paper includes name.	5	3	1	0
Title is included on paper.	5	3	1	0
Purpose of invention is written on paper.	5	3	1	0
Paper is neat.	5	3	1	0
Invention has a purpose.	10	6	3	0
Invention has a solution.	10	6	3	0
Invention works.	10	6	3	0
Share your invention with class.	10	6	3	0
Points earned				

BONUS POINTS

Write about your whole "invention process."	10	6	3	0
Total points for invention project				

demonstrated how to make corn cakes; he brought in an electric skillet and premeasured ingredients, and made corn cakes for the children to sample.

Invention Projects

Karen's Invention Project stemmed from a science unit on simple machines and the class reading of *The Gadget Wars* by Duffey (1991). The class had also read about other inventions such as the making of the choco-late chip cookie and about famous inventors such as Alexander Graham Bell. One child from the class came in and shared that he had learned how the potato chip was invented, and he taught this to the rest of the class. Karen then found text about this invention on the Internet, and children were invited to read it. Karen created the project assignment inviting families to help, explaining that the project must solve a problem or inconvenience (Table 7.2).

The children shared their inventions with the class, explaining the purpose. They were also to have a written description of the project. The children's inventions were delightful (Photos 7.4 and 7.5). In Karen's class-room one year, there was a remote control night-light, a spinning chalk

Photo 7.4
Inventing a pencil lead
holder

Photo 7.5
Inventing an automatic
dog feeder

holder, a pet cast-protector, and shoe and coat hanger. Families were highly involved in this project!

Reading Logs

One of the strategies Gayle uses to encourage children's reading is an every-day book checkout system in the classroom. The children may select a book each day to take home to read each evening and then return the

Figure 7.2
Reading Log

READING LOG

Week of _____

Student _____

This week, I read the following books:

Parent/child comments or questions for this week:

Figure 7.3
Home Reading Log

HOME READING LOG	Record all books read at home on this page. Include all books even if you are not making a response.				
Date	Title	Read Independently	Read With Help	Was Read To	Comments

following morning. This can be a book that they can read themselves or that someone at home can read to them. A weekly sheet goes home each Friday so that the children can record the titles of the books read daily (Figure 7.2). The sheet also includes a place for parent comments or questions about the reading or anything else they want to share with Gayle.

In Karen's classroom, students keep a running account of the books they've read at home in their reading log (Figure 7.3). This record helps the parents and teacher stay aware of the child's reading interests and choices.

Learning Logs

Another kind of homework approach Gayle has used is the learning log. At the beginning of the year, she wrote a letter to the parents explaining her view that children learn much from whatever they experience outside of school, and this can be viewed as "home" work (see Box 7.2). She elaborated on her assumption that she and the parents both wanted these experiences to lead to positive learning opportunities for the children. She then illustrated the many ways "academics" could be a part of everyday experiences. Dance and music lessons, sports and neighborhood play all have an academic dimension, if viewed in a different way. To help parents understand this perspective, Gayle wrote suggested activities for each subject area, illustrating the potential academic possibilities in everyday events. She then asked the parents to record what they and their children had done each week in each subject area, and defined that as the children's "homework."

Box 7.2
Learning-at-Home Letter

Dear Parents,

Let's talk about homework! I adopted a new concept of homework this past summer. I realized that you do a lot of educational things with your children outside of school, which is *home*work! So that I can understand what kinds of things you are working on at home and be supportive of your efforts, I need you to start documenting the work that your child does at home that contributes to his or her learning.

Times have changed. School is more child-centered now. Learning is a very active process in the classroom. As nice as it sounds to let your child do a worksheet in front of the TV while you finish up the supper dishes, it just doesn't make sense anymore. Learning can't be active at school and passive at home. Learning at home must reflect learning at school, and to accomplish that parents must be involved.

The beauty of this plan is that much of what you have been doing in your home as good parents supports this idea of active learning anyway. You may not have seen it as "homework" before, but that is what it is: work (learning) that is done at home.

This handbook should help you redirect your ideas on what the term *homework* means. I have included a few concrete ideas for learning activities in the home. This is, by no means, an all-inclusive list.

Because learning at home should be as varied as learning at school, I have included suggestions from all areas of the school curriculum. In the course of the week, you and your child should try activities from as many of the areas as possible. You will probably have favorites, and it is fine to repeat those as often as you want.

(continued)

Box 7.2 Continued

I suggest spending about an hour a night learning at home. You DO NOT have to do the activities at one time. You may prefer to do fifteen minutes here, twenty minutes there. Some nights may be so hectic for you that you may only get fifteen minutes in total. That's fine. Perhaps it fits your schedule better to do homework on the weekends. That's fine. Just try to get in about four hours a week.

Each Monday you will receive a log on which to record your family's activities for the week. It will be divided by subject rather than by days of the week in order to help you remember to include a wide variety of activities. The log may be completed by either you or your child; however, if you choose to do the writing, make sure that your child is also involved somehow.

Please return the log to me on Friday or on the following Monday. The logs help me know what extra learning your child has been involved in. We will file the Learning at Home logs here at school. Now, grab your children and enjoy this adventure that we call learning!

Sincerely,

Ms. Moore

It is important to note that of all Gayle's attempts at implementing innovative homework ideas, this one was the least successful. While we still think this approach is a good one for helping families build on their funds of knowledge in the home, it may need some face-to-face explanation. Had Gayle presented the idea at a Family Workshop rather than through written communication, more parents might have become involved. As it was, it may have been just too different from what families saw as legitimate homework.

Grandparent Involvement

As we mentioned in Chapter 6, many of the children in Gayle's classroom had strong connections with grandparents. Consequently, within her unit on Change Over Time, she involved the children in interviewing their grandparents to discover what their lives were like when they were six and seven years old (see Box 7.3).

For the culminating event of the study, the children invited their grandparents to school for lunch and a group presentation and discussion. The children shared what they learned from their interviews and what they thought were the most interesting changes that had taken place over the years. They then posed questions about other topics that they wanted the grandparents to address. The grandparents shared their remembrances, both good and bad, and their views of the present, both good and bad. That event became a touchstone for the remainder of the year, providing many opportunities for Gayle and the children to connect what they learned that day to what they studied and learned afterward. In addition, Gayle noticed that the grandparents attended school events more often than before, and her ties to the extended family seemed stronger.

Box 7.3
Grandparent Interview

1. What year were you born?
 1935

2. Where did you grow up? In a small town, city, or on a farm?
 In a small town

3. What did you normally eat for breakfast? Lunch? Dinner?
 biscuits and gravy, milk, eggs

4. How did you get to school every day?
 walked

5. What was school like? What subjects did you study?
 math, history, English

6. What was your favorite game that you played inside? Outside?
 Card games and softball

7. Did you have any chores? What were they?
 Carry coal and wood

8. Did you get an allowance? How much?
 15¢ each week

9. How many people were in your family?
 11

Special Project Badges

Carol explains,

Our badges were designed to enlist support for parents in other ways besides academics, again making connections between home and school. Pinning ceremonies are held three times a year. Parents and relatives are invited to attend, and we always have a big crowd (see Box 7.4).

The unifying intent across all of these examples is taking an easily understood and typical aspect of schooling—homework—and applying it in new ways and with the explicit purpose of connecting with families. As Gayle, Karen, and others have shown, homework can help teachers discover a great deal about students, engage families in authentic learning activities with personal meaning, and at the same time focus on academic content and skills.

Principal Carol Miller encourages students to earn badges at her school. The categories include Good Citizenship, Good Manners, Personal Growth, the Environment, Public Speaking, Community Service/Awareness—and a Home Project badge.

Box 7.4
McFerran Preparatory Academy

Home Project Badge

The McFerran Preparatory Academy stresses the importance of being a responsible person at home as well as at school. Family is a very important part of a student's life, and a family does many things for him/her. A student can also be a responsible member of the family by demonstrating his/her skills at home.

To earn the Home Project Badge, the Academy student may choose projects from the following list:

1. Take out the trash.
2. Make own bed.
3. Feed and care for a pet.
4. Set the table.
5. Clear the table after a meal.
6. Help wash and/or dry dishes after meals.
7. Clean one's own room.
8. Put books and/or toys away.
9. Hang up/Put away one's own clothes and/or put the clothes in the hamper.
10. Help with laundry projects (sorting clothing, loading washer, etc.).
11. Add any other new project that you would like to learn (must be approved by parent/guardian).

The following are guidelines for earning the Home Project Badge:

- **Kindergarten and Grade One**
 Choose two projects

 Grades Two and Three
 Choose three projects

 Grades Four and Five
 Choose four projects

- Each project must be done for four weeks (The project must be done at least 20 days in the four-week period). Student must design a chart to keep track of the days the project is performed. Chart should include the beginning and ending dates and the project that was performed. Parent/Guardian should sign the chart, indicating the child has completed the project.

TIPS FOR PRINCIPALS: HOW TO IMPLEMENT ■ FAMILY-CONNECTED HOMEWORK SCHOOLWIDE

Elementary principal John Finch suggests planning a "homework workshop" for families that involves them in homework-like activities. This can be a great way to help explain important concepts about homework (how much time is reasonable, how much involvement parents or guardians could or should have, the importance of reading each night, how to handle typical problems, etc.). This is especially important if you're trying out new ideas such at the ones in this chapter. And, it helps teachers learn more about the children and their families as they interact and work together.

> Middle school principal Dena Kent has plans for new approaches to homework at her school that connect more with families.

Dena Kent, a middle school principal, commented,

> I have some ideas that haven't been implemented that I'd like to see implemented throughout our school, an idea like double-entry journals. We're doing that in the classroom among peers, and it's a great strategy. But, I'd like to see that process done with parents as well. Perhaps in class if you are talking about a character in a novel who has difficulties growing up or adapting to change, that could be a journal entry initiated by the student. But, the double-entry journal could be written by a parent or a person in a parent role. I see that as being advantageous.
>
> Another idea has to do with the work parents do. I know that we have parents working in the field of science for example, in agriculture, or at the zoo. Or students may have an aunt or uncle in a particular job—real estate agent or mechanic or carpenter. I think with the right kind of assignment, our teachers could incorporate parent or other family members' involvement a little more than they are doing. I don't think we are doing a good job of getting their history, learning about their experiences, and helping the students see what these people—people they know very well—are doing as a result of their education and training.

SUMMARY TIPS FOR FAMILY-CONNECTED ■ HOMEWORK

Creating family-connected homework takes some planning. The following tips may help as you begin the process.

• Take a look at your usual homework assignments and activities. Do they tap into the funds of knowledge of your students and their families? Could any be redesigned to do so?

• Consider some new types of homework, similar to what Gayle and Karen have used. Which could work for you, even if modifications are needed?

- Talk with your colleagues about the ideas raised in this chapter and the examples provided. Brainstorm together about ways you could approach homework from this new perspective.

- Help parents understand your new ideas about homework, especially if they are a dramatic departure from what parents are used to at your school. Build time into Open House activities to discuss this. Have an example ready for everyone to practice, so they'll understand what you mean and what to expect.

- Develop a way for families to let you know what they think of the homework activities—what's working, what's confusing or difficult, what would help them help their children better.

- Involve your principal in your plans, including how you are taking care of any potential questions or confusions.

- Don't force family involvement. Make sure the work is flexible enough for families to get very involved or to show their support in a more modest way.

- Celebrate homework. Share it, but as often as you can, give a grade of "complete" or "not complete" rather than the more judgmental grades. However, if the work is not celebrated, then merely getting a "complete" may encourage sloppiness in some.

■ SUMMARY

This chapter presents ideas about a new approach to an old challenge— homework. If we want students to be engaged learners and to achieve academically, we believe homework has to change. The strategies we have presented share a common goal of using meaningful, family-connected homework as a way to involve families, learn from them, and help students academically. The teachers and principals who have used these ideas have gotten positive responses from both students and parents. Approached from a new perspective, homework can become yet another way to connect with families and work together for students' success.

Conclusion

As we reach the end of this book and think about having written it together, we realize how much the process has meant to us and that we are even more committed to the ideas now than when we began. This has truly been a collaborative effort. Time spent talking, brainstorming, drafting, rewriting, and talking some more has given us the chance to share the many perspectives we have as teachers, teacher educators, researchers, readers, and parents. In doing this, we've been able to expand our thinking and understandings; explore new insights; grapple with the challenges of teaching in new ways; and clarify our passionate commitments as educators. This collaboration, we believe, has resulted in a much richer book than if any one of us had written it alone.

What is this book's main message? In reflecting on that question and what we have advocated, we realize our main message is about a new vision of teaching. The kind of teaching we're talking about—that connects with families and builds on their funds of knowledge—requires a fundamental rethinking of what teaching is. This is not an "add-on" to the curriculum or a special, short-term classroom project. Instead, our focus is on reframing teachers' aims, commitments, and practices in ways that enable more children to succeed in school. Only by reaching out and connecting with families can teachers have the knowledge needed to maximize student learning.

Yes, individual teachers can decide to put the ideas of this book into practice; however, if this is to happen in a more systemic way, the support of principals and district-level administrators is critical. We hope all who read this book, no matter what their role, will find the many concrete examples useful as a starting point. Rather than feeling overwhelmed by the whole, we encourage people to take just the first step. We hope, too, to hear from readers who try some of the ideas and then develop new ones of their own. We see much value in a network of people supporting and learning from one another as we strive to enable the success of all learners through stronger school-family connections. Our children deserve nothing less than our best efforts to develop such relationships.

As we began this book, we shared a poem one of Karen's students wrote about her, and we close with a poem from one of Gayle's students. In each, students' voices remind us of the enduring effect of teachers who take the time to know their students well.

Ms. Moore

The loving

caring

nice

humorous

person,

who teaches kids

who sometimes don't listen,

but still reaches

and doesn't

give up.

By Chris Brown

Resource A

Books of Interest to Elementary Students and Their Families

AGRICULTURE ■

Aliki. (1992). *Milk: From cow to carton*. New York: HarperCollins.

Arnow, J. (1986). *Hay from seed to feed*. New York: Alfred A. Knopf.

Ling, M. (1994). *On the farm*. London: Covent Garden Books.

Merrill, C. (1973). *A seed is a promise*. New York: Scholastic.

Robbins, K. (1992). *Make me a peanut butter sandwich and a glass of milk*. New York: Scholastic.

Robinson, F. (1994). *Vegetables, vegetables!* Chicago: Children's Press.

BIOGRAPHIES ■

Adler, D. (1989). *A picture book of Martin Luther King, Jr.* New York: Holiday House.

Adler, D. (1996). *Martin Luther King, Jr.: Free at last*. New York: Holiday House.

Boone-Jones, M. (1968). *Martin Luther King, Jr.: A picture story*. Chicago: Children's Press.

Brenner, M. (1994). *Abe Lincoln's hat*. New York: Random House.

Brenner, R. J. (2000). *Mark McGuire*. New York: Beechtree.

Brenner, R. J. (2000). *Sammy Sosa*. New York: Beechtree.

Cline-Ransom, L. (2000). *Satchel Paige*. New York: Simon & Schuster.

Cooney, B. (1996). *Eleanor*. New York: Viking Press.

Cooper, F. (1996). *Mandela: From the life of the South African statesman*. New York: Philomel Books.

Culling, M. (1999). *Eleanor everywhere: The life of Eleanor Roosevelt*. Random House.

Esiason, B. (1998). *A boy named Boomer*. New York: Scholastic.

Haskins, J., & Benson, K. (1991). *Space challenger: The story of Guion Bluford*. Boston: Houghton Mifflin.

Jacobs, W. J. (1999). *Mother Theresa: Helping the poor*. Brookfield, CT: Millbrook Press.

Krull, K. (1996). *Wilma Unlimited: How Wilma Rudolph became the world's fastest woman*. San Diego, CA: Harcourt Brace.

Lepscky, I. (1982). *Amadeus Mozart*. Hauppage, NY: Barron's.

Lepscky, I. (1984). *Pablo Picasso*. Hauppauge, NY: Barron's.

Lundell, M. (1995). *A girl named Helen Keller*. New York: Scholastic.

Marshall, H. (1997). *The Ruby Bridges story*. New York: Disney Press.

Martin, J. B. (1998). *Snowflake Bentley*. New York: Scholastic.

Marzollo, J. (1993). *Happy birthday Martin Luther King, Jr.* New York: Scholastic.

McGovern, A. (1992). *If you grew up with Abraham Lincoln*. New York: Scholastic.

Ringold, F. (1995). *My dream of Martin Luther King*. New York: Crown Publishers.

Rolka, G. (1994). *100 women who shaped world history*. San Mateo, CA: Bluewood Books.

Skira-Venturi, R. (1996). *A weekend with Renoir*. New York: Rizzoli.

Venezia, M. (1989). *Da Vinci: Getting to know the world's greatest artists*. Chicago: Children's Press.

Zeldis, M. (2000). *Sisters in strength: African American women who made a difference*. New York: Henry Holt.

■ CARING/FEELINGS

Carlson, N. (1990). *Arnie and the new kid*. New York: Viking.

Cooper, M. (1998). *Gettin' through Thursday*. New York: Lee and Low Books.

dePaola, T. (1981). *Now one foot, now the other*. New York: Putnam.

Fox, M. (1984). *Wilfrid Gordon McDonald Partridge*. New York: Harcourt Brace.

Havill, J. (1986). *Jamaica's find*. Boston: Houghton Mifflin.

Henkes, K. (1996). *Lilly's purple plastic purse*. New York: Greenwillow.

Hill, E. (1991). *Evan's corner*. New York: Viking Children's Books.

Joose, B. M. (1991). *Mama, do you love me?* San Francisco: Chronicle Books.

Kraus, R. (1971). *Leo the late bloomer*. New York: Scholastic.

Lionni, L. (1967). *Frederick*. New York: Knopf.

Yolen, J. (1987). *Owl moon*. New York: Philomel Books.

COMMUNITIES/NEIGHBORHOODS ■

Bunting, E. (1994). *Smoky night*. San Diego, CA: Harcourt.

Cooney, B. (1982). *Miss Rumphius*. New York: Puffin.

Cosby, B. (1997). *The treasure hunt*. New York: Scholastic

Cosby, B. (1998). *Shipwreck Saturday*. New York: Scholastic.

Fleischman, P. (1998). *Seedfolks*. New York: HarperTrophy.

Gray, N. (1988). *A country far away*. New York: Orchard.

Knight, M. B. (1992). *Talking walls*. Gardiner, ME: Tilbury Press.

Say, A. (1993). *Grandfather's journey*. Boston: Houghton Mifflin.

Taylor, M. (1987). *The gold Cadillac*. New York: Puffin.

Ziefert, H. (1986). *A new coat for Anna*. New York: Knopf.

FAMILIES ■

Anholt, C. (1990). *Good days, bad days*. New York: Putnam.

Blaine, M. (1986). *The terrible thing that happened at our house*. New York: Four Winds Press.

Caines, J. (1982). *Just us women*. New York: HarperTrophy.

Greenfield, E. (1988). *Grandfather's face*. New York: Philomel Books.

Heo, Y. (1994). *One afternoon*. New York: Orchard.

Houston, G. (1992). *My great-aunt Arizona*. New York: HarperCollins.

Keats, E. J. (1967). *Peter's chair*. New York: Harper & Row.

Kennedy, J. 1998). *Lucy goes to the country*. Los Angeles: Alyson Wonderland Publications.

Kindersley, B., & Kindersley, A. (1997). *Celebrations! Children just like me*. New York: DK Publishing.

Lyon, G. E. (1991). *Cecil's story*. New York: Orchard.

Miller, W. (1994). *Zora Hurston and the chinaberry tree*. New York: Lee and Low Books.

Morris, A. (1990). *Loving*. New York: Lothrop, Lee & Shepard Books.

Pellegrini, N. (1991). *Families are different*. New York: Holiday House.

Roberts, N. (1983). *Barbara Jordan: The great lady from Texas*. Chicago: Children's Press.

Say, A. (1993). *Grandfather's journey*. Boston: Houghton Mifflin.

Willhoite, M. (1990). *Daddy's roommate*. Los Angeles, CA: Alyson Wonderland Books.

Williams, V. (1982). *A chair for my mother*. New York: Greenwillow.

■ FOOD

Barrett, J. (1978). *Cloudy with a chance of meatballs*. New York: Macmillan.

Dooley, N. (1991). *Everybody cooks rice*. Minneapolis: Carolrhoda Books.

Ehlert, L. (1989). *Eating the alphabet: Fruits and vegetables from A to Z*. New York: Harcourt Brace.

Hines, A. G. (1986). *Daddy makes the best spaghetti*. New York: Clarion.

Hoban, R. (1964). *Bread and jam for Frances*. New York: HarperTrophy.

Morris, A. (1989). *Bread bread bread*. New York: Scholastic.

Polacco, P. (1990). *Thundercake*. New York: Philomel Books.

Sharmat, M. (1980). *Gregory, the terrible eater*. New York: Four Winds.

■ FRIENDSHIP

Cosby B. (1997). *The best way to play*. New York: Scholastic.

Henkes, K. (1989). *Jessica*. New York: Greenwillow.

Johnson, D. B. (2000). *Henry hikes to Fitchburg*. Boston: Houghton Mifflin.

Lyon, G. E. (1989). *Together*. New York: Orchard.

Marshall, J. (1972). *George and Martha*. Boston: Houghton Mifflin.

Polacco, P. (1992). *Mrs. Katz and Tush*. New York: Bantam.

Viorst, J. (1974). *Rosie and Michael*. New York: Macmillan.

GRANDPARENTS ■

Aliki. (1979). *The two of them*. New York: Greenwillow.

Bunting, E. (1989). *The Wednesday surprise*. New York: Houghton Mifflin.

Crews, D. (1991). *Bigmamas*. New York: Greenwillow.

dePaola, T. (1973). *Nana upstairs, Nana downstairs*. New York: Putnam.

Dorros, A. (1991). *Abuela*. New York: E. P. Dutton.

Flournoy, V. (1985). *The patchwork quilt*. New York: Dial.

Fox, M. (1989). *Shoes from Grandpa*. New York: Orchard.

Hines, A. G. (1993). *Grandma gets grumpy*. Boston: Houghton Mifflin.

Lyon, G. E. (1990). *Basket*. New York: Orchard.

MacLachlan, P. (1980). *Through Grandpa's eyes*. New York: Harper.

Martin, B., & Archambault, J. (1987). *Knots on a counting rope*. New York: Henry Holt.

Martin, C. L. G. (1991). *Three brave women*. New York: Macmillan.

Say, A. (1993). *Grandfather's journey*. New York: Scholastic.

Wild, M. (1993). *Our Granny*. Boston: Houghton Mifflin.

HISTORY/HISTORICAL FICTION ■

Ash, M. (1989). *The story of the women's movement*. Chicago: Children's Press.

Colbert, J., & Harms, A. M. (1998). *Dear Dr. King: Letters from today's children to Martin Luther King, Jr*. New York: Hyperion Books for Children.

Donnelly, J. (1991). *A wall of names: The story of the Vietnam Veterans Memorial*. New York: Random House.

Fritz, J. (1987). *Shhh! We're writing the Constitution*. New York: Putnam.

Levin, E. (1990). *If you lived at the time of Martin Luther King*. New York: Scholastic.

Lowry, L. (1998). *Number the stars*. New York: Laureleaf.

MacLachlan, P. (1985). *Sarah plain and tall*. New York: HarperTrophy.

Polacco, P. (1994). *Pink and say*. New York: Philomel Books.

Ringold, F. (1999). *If a bus could talk: The story of Rosa Parks*. New York: Simon & Schuster.

MATHEMATICS ■

Allen, P. (1982). *Who sank the boat?* New York: Putnam/Grosset.

Briggs, R. (1970). *Jim and the beanstalk*. New York: McCann.

Burns, M. (1994). *The greedy triangle*. New York: Scholastic.

Clement, R. (1991). *Counting on Frank*. Milwaukee: Garth Stevens.

Gunson, C. (1995). *Over on the farm*. New York: Scholastic.

Hutchins, P. (1986). *The doorbell rang*. New York: Greenwillow.

McMillan, B. (1991). *Eating fractions*. New York: Scholastic.

Murphy, S. J. (1996). *Get up and go*. New York: Scholastic.

Murphy, S. J. (1997). *Elevator magic*. New York: Scholastic.

Scieszha, J., & Smith, L. (1995). *Math curse*. New York: Viking Children's Books.

Tang, G. (2001). *The grapes of math*. New York: Scholastic.

■ SHELTER

Barton, B. (1981). *Building a house*. New York: Greenwillow.

Gibbons, G. (1990). *How a house is built*. New York: Holiday House.

Hoberman, M. A. (1982). *A house is a house for me*. New York: Puffin.

Morris, A. (1992). *Houses and homes*. New York: Lothrop, Lee, & Shepard.

■ SCIENCE

Bash, B. (1989). *Desert giant: The world of the saguaro cactus*. New York: Scholastic.

Benjamin, C. (1999). *Footprints in the sand*. New York: Scholastic.

Biddulph, F., & Biddulph, J. (1992). *Machines*. Bothell, WA: Wright Group.

Black, S. W. (1999). *Plenty of penguins*. New York: Scholastic.

Branley, F. M. (1981). *The planets in our solar system*. New York: HarperCollins

Branley, F. M. (1998). *Floating in space*. New York: HarperCollins.

Carle, E. (1990). *A house for hermit crab*. New York: Scholastic.

Cherry, L. (1990). *The great kapok tree: A tale of the Amazon rain forest*. New York: Harcourt Brace.

dePaola, T. (1975). *The cloud book*. New York: Scholastic.

Gill, P. (1990). *Birds*. Mahwah, NJ: Troll Associates.

Griffin, M., & Griffin, R. (1992). *It's a gas!* Toronto, Canada: Kids Can Press.

Gross, R. B. (1994). *A book about your skeleton*. New York: Scholastic.

Hann, J. (1991). *How science works: 100 ways parents and kids can share the secrets of science*. London: Dorling Kindersley.

Keefe, K. (1996). *Those aren't Teddy bears in our parks*. Toronto, Canada: Bruin Books.

Lauber, P. (1989). *Volcano: The eruption and healing of Mount St. Helens*. New York: Bradbury.

Marzollo, J. (1996). *I'm a seed*. New York: Scholastic.

McNulty, F. (1994). *Dancing with manatees*. New York: Scholastic.

Moche, D. L. (1988). *Amazing space facts*. New York: Western Publishing.

More, D. (1990). *Trees and leaves*. Mahwah, NJ: Troll Associates.

Naden, C. J. (1979). *I can read about creepy crawlers*. Mahwah, NJ: Troll Associates.

Nicolson, C. 1996). *The Earth*. Toronto, Canada: Kids Can Press.

Oppenheim, J. (1995). *Have you seen trees?* New York: Scholastic.

Pallotta, J. (1989). *The yucky reptile alphabet book*. Watertown, ME: Charlesbridge Books.

Pallotta, J. (1992). *The icky bug alphabet book*. Watertown, ME: Charlesbridge Books.

Parker, N. W., & Wright, J. R. (1987). *Bugs*. New York: Greenwillow.

Petty, K. (1990). *Bears*. Hauppauge, NY: Barron's Books.

Provensen, A., & Provensen, M. (1992). *El libro de las estaciones (A book of the seasons)*. New York: Random House.

Roe, R. (1987). *How speedy is a cheetah? Fascinating facts about animals*. New York: Grosset & Dunlap.

Shaw, G. (1999). *Shadows everywhere*. New York: Scholastic.

Silver, D. (1993). *One small square backyard*. New York: Scientific American Books for Young Readers.

Thomson, R. (2000). *Dinosaur's day*. New York: DK Publishing.

Walpole, B. (1988). *75 science experiments to amuse and amaze your friends*. New York: Random House.

Resource B

Books of Interest to Middle School Students and Their Families

ABANDONMENT ■

Voigt, C. (1983). *Dicey's song*. New York: Atheneum.

ADVENTURE ■

Harrer, H. (1982). *Seven years in Tibet*. Los Angeles: Jeremy P. Tarcher.

AFRICAN AMERICAN EXPERIENCE (HISTORY) ■

Curtis, C. (1995). *The Watsons go to Birmingham*. New York: Bantam Books.

Lee, H. (1960). *To kill a mockingbird*. New York: J. B. Lippincott.

Taylor, M. (1976). *Roll of thunder, hear my cry*. New York: Dial.

ANIMALS ■

Herriot, J. (1992). *Every living thing*. New York: St. Martin's.

Mowat, F. (1979). *Never cry wolf*. New York: Bantam Books.

■ BIOGRAPHY

Freedman, R. (1988). *Lincoln: A photobiography*. New York: Clarion.

Freedman, R. (1993). *Eleanor Roosevelt*. New York: Clarion.

Paulson, G. (1991). *Woodsong*. New York: Bradbury.

■ COMING OF AGE

Ehrlich, A. (Ed.). (1996). *When I was your age: Original stories about growing up*. Cambridge, MA: Candlewick.

Zindel, P. (1968). *The pigman*. New York: Harper.

■ DEATH OF A FRIEND

Paterson, K. (1977). *Bridge to Terabithia*. New York: Crowell.

■ DISASTER

Natural

Junger, S. (1998). *The perfect storm: A true story of men against the sea*. New York: HarperCollins.

Nuclear

Hesse, K. (1995). *Phoenix rising*. New York: Scholastic.

O'Brien, R. (1975). *Z for Zachariah*. New York: Atheneum.

Virus

Nelson, O. (1977). *The girl who owned a city*. New York: Bantam Doubleday.

■ DIVORCE

Conly, J. (1995). *Trout summer*. New York: Scholastic.

Voigt, C. (1984). *A solitary blue*. New York: Atheneum.

■ DRUGS/ALCOHOL

Anonymous. (1976). *Go ask Alice*. New York: Avon Books.

Fleischman, P. (1998). *Whirligig*. New York: Random House.

ENVIRONMENT ■

Klass, D. (1974). *California blue*. New York: Scholastic.

FAIRYTALES ■

Levine, G. (1997). *Ella enchanted*. New York: Scholastic.

McKinley, R. (1993). *Beauty*. New York: HarperTrophy.

FAMILY HISTORY ■

Nixon, J. (1977). *Search for the shadowman*. New York: Bantam Doubleday.

FAMILY RELATIONSHIPS ■

Creech, S. (1997). *Chasing Redbird*. New York: Scholastic.

Death of a Parent

Berg, E. (1993). *Durable goods*. New York: Random House.

Hesse, K. (1997). *Out of the dust*. New York: Scholastic.

Peck, R. (1977). *A day no pigs would die*. New York: Knopf.

White, R. (1997). *Belle Prater's boy*. New York: Yearling Books.

Sibling Rivalry

Bloor, E. (1997). *Tangerine*. New York: Scholastic.

FOSTER CHILDREN ■

Byars, B. (1977). *The pinballs*. New York: Harper & Row.

Paterson, K. (1987). *The Great Gilly Hopkins*. New York: HarperTrophy.

FRIENDS ■

Johnson, A. (1998). *Heaven*. New York: Simon & Schuster.

GANGS/BULLIES/HARASSMENT ■

Cormier, R. (1986). *The chocolate war*. New York: Bantam Doubleday Dell.

Hinton, S. (1967). *The outsiders*. New York: Dell.

Lipsyte, R. (1977). *One fat summer*. New York: HarperTrophy.

Myers, W. (1988). *Scorpions*. New York: Harper & Row.

■ HANDICAPS

Mental

Fenner, C. (1995). *Yolanda's genius*. New York: Simon & Schuster.

Wood, J. (1995). *When pigs fly*. New York: Putnam/Grosset.

Physical

Voight, C. (1986). *Izzy Willy-Nilly*. New York: Aladdin Paperbacks.

■ HISPANIC EXPERIENCE

Cisneros, S. (1991). *The house on Mango Street*. New York: Vintage.

Jimenez, F. (1977). *The circuit*. New York: Scholastic.

Soto, G. (1985). *Living up the street*. New York: Bantam Doubleday Dell.

■ THE HOLOCAUST

Frank, A. (1952). *Diary of a young girl*. New York: Doubleday.

Lowry, L. (1989). *Number the stars*. New York: Houghton Mifflin.

Wiesel, E. (1996). *Night*. New York: Hill & Wang.

Yolen, J. (1988). *The devil's arithmetic*. New York: Scholastic.

■ IDENTITY

Blume, J. (1986). *Are you there, God? It's me, Margaret*. New York: Yearling Books.

Cooney, C. (1961). *Face on the milk carton*. New York: Bantam Doubleday Dell.

Hesse, K. (1996). *Music of the dolphins*. New York: Scholastic.

■ IMMORTALITY

Babbitt, N. (1975). *Tuck everlasting*. New York: Farrar, Strauss & Giroux.

■ PETS

Fleischman, S. (1992). *Jim ugly*. New York: Dell.

Naylor, P. (1992). *Shiloh*. New York: Dell/Yearling.

North, S. (1991). *Rascal*. New York: Scholastic.

Rawls, W. (1961). *Where the red fern grows*. New York: Doubleday.

SCHOOL ■

Danziger, P. (1998). *The cat ate my gymsuit*. New York: Putnam/Grosset.

SOCIETY (POLITICS) ■

Lowry, L. (1994). *The giver*. New York: Bantam Doubleday Dell.

SPORTS ■

Brooks, B. (1996). *The moves make the man*. New York: HarperCollins.

Deuker, C. (1994). *Heart of a champion*. New York: Avon.

Klass, D. (1996). *Danger zone*. New York: Scholastic.

SURVIVAL ■

George, J. (1974). *Julie of the wolves*. New York: HarperTrophy.

Paulsen, G. (1987). *Hatchet*. New York: Puffin.

Sachar, L. (1998). *Holes*. New York: Dell/Yearling.

TWINS ■

Paterson, K. (1980). *Jacob have I loved*. New York: Crowell.

WAR ■

Hunt, I. (1986). *Across five Aprils*. New York: Berkley Books.

Myers, W. (1988). *Fallen angels*. New York: Scholastic.

References

Archambault, J., & Martin, B. (1985). *The ghost-eye tree*. New York: Henry Holt.

Atwell, N. (1998). *In the middle*. Portsmouth, NH: Boynton/Cook.

Ayers, M., Fonseca, J. D., Andrade, R., & Civil, M. (2001). Creating learning communities: The build your dream-house unit. In E. McIntyre, A. Rosebery, & N. González (Eds.), *Classroom diversity: Connecting curriculum to students' lives* (pp. 92-99). Portsmouth, NH: Heinemann Educational Books.

Ayers, W. (1993). *To teach: The journey of a teacher*. New York: Teachers College Press.

Bloome, D., Katz, L., Solsken, J., Willett, J., & Wilson-Keenean, J. (2000). Interpellations of family/community and classroom literacy practices. *The Journal of Educational Research, 93*, 155-164.

Bruner, J. (1996). *The culture of education*. Cambridge, MA: Harvard University Press.

Carpenter, T., Fenneman, E., & Franke, M. (1996). Cognitively guided instruction: A knowledge base for reform in primary mathematics instruction. *Elementary School Journal, 97*, 3-20.

Casper, V., & Schultz, S. B. (1999). *Gay parents/straight schools*. New York: Teachers College Press.

Conant, F. R., Rosebery, A., Warren, B., & Hudicourt-Barnes, J. (2001). The sound of drums. In E. McIntyre, A. Rosebery, & N. González (Eds.), *Classroom diversity: Connecting curriculum to students' lives* (pp. 51-60). Portsmouth, NH: Heinemann Educational Books.

Crafton, L. K. (1996). *Standards in practice: Grades K-2* (National Council of Teachers of English). Urbana, IL: NCTE.

Deffendall, L. (2001, August 4). Principal pounds pavement. *Lexington Herald-Leader*.

Delpit, L. (1995). *Other people's children: Cultural conflict in the classroom*. New York: New Press.

Duffey, B. (1991). *The gadget wars*. New York: Viking Press.

Dyson, A.H. (1984). Learning to write/Learning to do school: Young children solving the written language puzzle. *Language Arts*, 204-214.

Edwards, P. A. (1999). *A path to follow: Learning to listen to parents*. Portsmouth, NH: Heinemann.

Epstein, J. L. (1986). Parents' reactions to teacher practices of parent involvement. *The Elementary School Journal, 86*, 277-294.

Epstein, J. L., Coates, L., Salinas, K. C., Sanders, M. G., & Simon, B. S. (1997). *School, family, and community partnerships: Your handbook for action*. Thousand Oaks, CA: Corwin Press.

Foster, M., & Peele, T. (2001). Ring my bell: Contextualizing home and school in an African American community. In E. McIntyre, A. Rosebery, & N. González (Eds.), *Classroom diversity: Connecting curriculum to students' lives* (pp. 27-36). Portsmouth, NH: Hienemann.

Freppon, P. A. (2001). *What it takes to be a teacher.* Portsmouth, NH: Heinemann.

Gee, J. (1990). *Social linguistics and literacies: Ideology in discourse.* Bristol, PA: Falmer.

González, N. E. (1995). The funds of knowledge for teaching project. *Practicing Anthropology, 17,* 3-6.

Gorman, J. C., & Balter, L. (1997). Culturally sensitive parent education: A critical review of quantitative research. *Review of Educational Research, 67,* 339-369.

Graves, D., & Hansen, J. (1983). The author's chair. *Language Arts, 60,* 176-183.

Grissmer, D. (1998). *Report to the Center for Research on Education, Diversity, and Excellence (CREDE).* Santa Cruz, CA: CREDE.

Heath, S. B. (1983). *Ways with words: Language, life, and work in communities and classrooms.* Cambridge: Cambridge University Press.

Hoover-Dempsey, K. V., & Sandler, H. M. (1997). Why do parents become involved in their children's education? *Review of Educational Research, 67,* 3-42.

Hornby, G. (2000). *Improving parental involvement.* London: Cassell Books.

International Reading Association. (2000). *Excellent reading teachers: A position statement of the International Reading Association.* Newark, DE: IRA.

John-Steiner, V. (2000). *Creative collaboration.* Oxford: Oxford University Press.

Johnson, E. B. (2000). *Contextual teaching and learning.* Thousand Oaks, CA: Corwin Press.

Jordan, C. (1985) Translating culture: From ethnographic information to educational program. *Anthropology and Education Quarterly 16,* 105-123.

Jordan, C. (1995). Creating cultures of schooling: Historical and conceptual background of the KEEP/Rough Rock Project. *The Bilingual Research Journal, 19*(1), 83-100.

Kentucky Early Learning Profile (KELP). (1992). Frankfort: Kentucky Department of Education.

Kyle, D. W., McIntyre, E., & Moore, G. (2001). Connecting mathematics instruction with the families of young children. *Teaching Children Mathematics, 8*(2), 80-86.

Lane, B.(1998). *The reviser's toolbox.* Shoreham, VT: Discover Writing Press.

Lareau, A. (2000). *Home advantage: Social class and parental intervention in elementary education.* New York: Rowan and Littlefield.

Lee, C. D. (1995). A culturally based cognitive apprenticeship: Teaching African American high school students skills in literacy interpretation. *Reading Research Quarterly, 30,* 608-630.

López, G. R., Scribner, J. D., & Mahitivanichcha, K. (2001). Redefining parental involvement: Lessons from high-performing migrant-impacted schools. *American Educational Research Journal, 38,* 253-288.

McCarthy, S. (1997). Connecting home and school literacy practices in classrooms with diverse populations. *Journal of Literacy Research, 29,* 145-182.

McCarthy, S. (2000). Home-school connections: A review of the literature. *The Journal of Educational Research, 93,* 145-154.

McDermott, R. (1987). Achieving school failure: An ethnographic approach to illiteracy and social stratification. In G. Spindler & L. Spindler (Eds.), *Education and cultural process: Anthropological approaches* (pp. 173-209). Prospect Heights, IL: Waveland.

McIntyre, E. (1997). *Project READ: A handbook for teachers doing early reading intervention.* Shelbyville, KY: OVEC Schools.

McIntyre, E., Kyle, D. W., Moore, G., Sweazy, R. A., & Greer, S. (2001). Linking home and school through family visits. *Language Arts, 78*(3), 264-272.

McIntyre, E., Rosebery, A., & Gonzalez, N. (2001*). Classroom diversity: Connecting curriculum to students' lives.* Portsmouth, NH: Heinemann Educational Books.

McIntyre, E., Sweazy, R. A., & Greer, S. (2001). Agricultural field day: Linking rural cultures to school lessons. In E. McIntyre, A. Rosebery, & N. González (Eds.), *Classroom diversity: Connecting curriculum to students' lives* (pp. 76-84). Portsmouth, NH: Heinemann Educational Books.

Michaels, S. (1985). Hearing the connections in children's oral and written discourse. *Journal of Education, 167,* 36-56.

Moll, L., Amanti, C., Neff, D., & Gonzalez, N. (1992). Funds of knowledge for teaching: Using a qualitative approach to connect homes and classrooms. *Theory Into Practice, 31*(2), 132-141.

Moll, L., & González, N. (1993). Lessons from research with language minority children. *Journal of Reading Behavior, 26,* 439-456.

Moll, L. C. (1992). Bilingual classrooms and community analysis: Some recent trends. *Educational Researcher, 21*(2), 20-24.

National Council of Teachers of English (NCTE). (1996). *Standards for the English language arts.* Newark, DE: International Reading Association; and Urbana, IL: National Council of Teachers of English.

National Council of Teachers of Mathematics (NCTM). (1989). *Curriculum and evaluation standards for school mathematics.* Reston, VA: Author.

Newmann, F. M. (Ed.). (1996). *Authentic achievement: Restructuring schools for intellectual quality.* San Francisco: Jossey-Bass.

Newmann, F. M., Secada, W. G., & Wehlage, G. (1995). *A guide to authentic instruction and assessment: Vision, standards, and scoring.* Madison: Wisconsin Center for Educational Research at the University of Wisconsin.

Powell, R., & Cantrell, S. (2001). Saving Black Mountain: Critical literacy in Appalachia. *The Reading Teacher.*

Prelutsky, J. (1987). *Nightmares: Poems to trouble your sleep.* New York: Greenwillow Books.

Purcell-Gates, V. (1995). *Other people's words: The cycle of low literacy.* Cambridge, MA: Harvard University Press.

Taylor, D., & Dorsey-Gaines, C. (1988). *Growing up literate: Learning from inner-city families.* Portsmouth, NH: Heinemann.

Teale, W. H. (1986). Home background and young children's literacy development. In W. H. Teale & E. Sulzby (Eds.), *Emergent literacy: Writing and reading* (pp. 173-206). Norwood, NJ: Ablex.

Tharp, R. (2001). *Claims and evidence: The effectiveness of the five standards for effective pedagogy* [White paper]. Center for Research on Education, Diversity, and Excellence, University of California, Santa Cruz.

Tharp, R., & Gallimore, R. (1993). *Rousing minds to life: Teaching, learning and schooling in social context*. Cambridge: Cambridge University Press.

Tharp, R. G., Estrada, P., Dalton, S., & Yamauchi, L. (2000). *Teaching transformed: Achieving excellence, fairness, inclusion, and harmony*. Boulder, CO: Westview.

Valdés, G. (1996). *Con respecto: Bridging the distances between culturally diverse families and schools*. New York: Teachers College Press.

Vélez-Ibáñez, C., & Greenberg, J. (1992). Formation and transformation of funds of knowledge among U.S. Mexican households. *Anthropology and Education Quarterly, 23*(4), 313-335.

Vogt, L. A., Jordan, C., & Tharp, R. G. (1992). Explaining school failure, producing school success: Two cases. In E. Jacob & C. Jordan (Eds.), *Minority education: Anthropological perspectives* (Vol. 18, pp. 53-66). Norwood, NJ: Ablex.

Vopat, J. (1994). *The parent project: A workshop approach to parent involvement*. York, ME: Stenhouse.

Vygotsky, L. S. (1978). *Mind in society: The development of higher psychological processes*. Cambridge, MA: Harvard University Press.

Wells, G., & Chang-Wells, G. L. (1992). *Constructing knowledge together: Classrooms as centers of inquiry and literacy*. Portsmouth, NH: Heinemann.

Wollman-Bonilla, J. (2000). *Family message journals: Teaching writing through family involvement*. Urbana, IL: National Council of Teachers of English.

Index